BASICS

FILM-MAKING

03

directing
fiction

Ethical: aware-
ness/
reflect-
ion/
debate

academia

An AVA Book
Published by AVA Publishing SA
Rue des Fontenailles 16
Case Postale
1000 Lausanne 6
Switzerland
Tel: +41 786 005 109
Email: enquiries@avabooks.ch

Distributed by Thames & Hudson
(ex-North America)
181a High Holborn
London WC1V 7QX
United Kingdom
Tel: +44 20 7845 5000
Fax: +44 20 7845 5055
Email: sales@thameshudson.co.uk
www.thamesandhudson.com

Distributed in the USA & Canada by:
Ingram Publisher Services Inc.
1 Ingram Blvd.
La Vergne, TN 37086
USA
Tel: +001 866 400 5351
Fax: +001 800 838 1149
E-mail: customer.service@
ingrampublisherservices.com

English Language Support Office
AVA Publishing (UK) Ltd.
Tel: +44 1903 204 455
Email: enquiries@avabooks.ch

ISBN 978-2-940411-00-9

10 9 8 7 6 5 4 3 2 1

Design by Darren Lever

Production by AVA Book Production Pte. Ltd.,
Singapore
Tel: +65 6334 8173
Fax: +65 6259 9830
Email: production@avabooks.com.sg

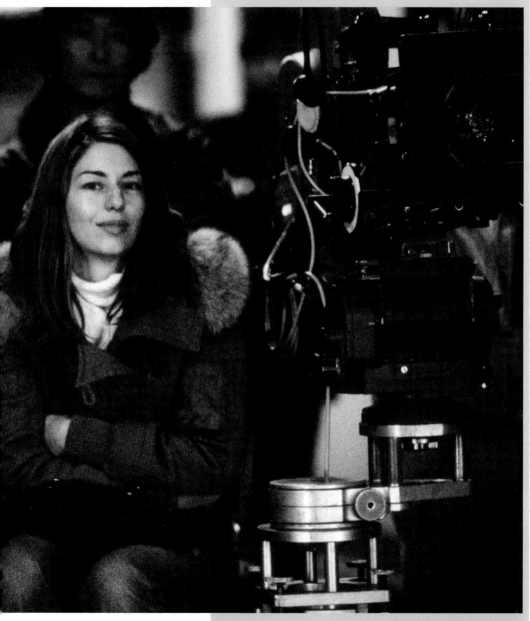

**Lost in Translation
(dir: Sofia Coppola 2003)**

The innovative film-maker Sofia Coppola prepares for action on the set of *Lost in Translation*. As the daughter of Francis Ford Coppola, Sofia is part of Hollywood royalty, yet she maintains a unique vision in the factory system.

Table of contents

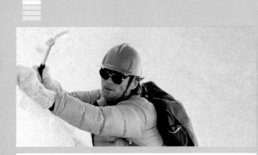

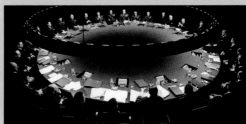

Directing Fiction

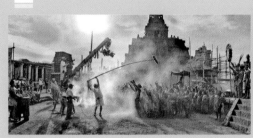

Table of contents

This book aims to provide you with a detailed introduction to the art and craft of directing a fiction film. Unlike many texts on directing, this book can be read in two distinct ways. Read through *Directing Fiction* from beginning to end in sequence, and discover the process by which a director develops a concept from initial idea through to finished film; or dip into it at leisure as you work to develop your own film, and find guidance on the many stages involved in realising your own ideas.

There are many practical pointers running throughout the book to help you think creatively, get to grips with your film and to guide you through the tricky bits – in the form of exercises, techniques and tips from industry professionals. We have devised these to both help improve your directing skills and to boost your powers of persuasion.

A running glossary explains key terms clearly and precisely

Captions illustrate stills from the work of successful directors

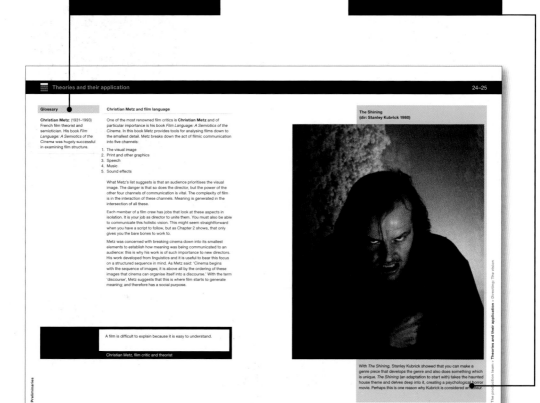

Glossary

Christian Metz: (1931–1993) French film theorist and semiotician. His book *Film Language: A Semiotics of the Cinema* was hugely successful in examining film structure.

Christian Metz and film language

One of the most renowned film critics is **Christian Metz** and of particular importance is his book *Film Language: A Semiotics of the Cinema*. In this book Metz provides tools for analysing films down to the smallest detail. Metz breaks down the act of filmic communication into five channels:

1. The visual image
2. Print and other graphics
3. Speech
4. Music
5. Sound effects

What Metz's list suggests is that an audience prioritises the visual image. The danger is that so does the director, but the power of the other four channels of communication is vital. The complexity of film is in the interaction of these channels. Meaning is generated in the intersection of all these.

Each member of a film crew has jobs that look at these aspects in isolation. It is your job as director to unite them. You must also be able to communicate this holistic vision. This might seem straightforward when you have a script to follow, but as Chapter 2 shows, that only gives you the bare bones to work to.

Metz was concerned with breaking cinema down into its smallest elements to establish how meaning was being communicated to an audience: this is why his work is of such importance to new directors. His work developed from linguistics and it is useful to bear this focus on a structured sequence in mind. As Metz said: 'Cinema begins with the sequence of images; it is above all by the ordering of these images that cinema can organise itself into a discourse.' With the term 'discourse', Metz suggests that this is where film starts to generate meaning; and therefore has a social purpose.

A film is difficult to explain because it is easy to understand.

Christian Metz, film critic and theorist

The Shining
(dir: Stanley Kubrick 1980)

With *The Shining*, Stanley Kubrick showed that you can make a genre piece that develops the genre and also does something which is unique. *The Shining* (an adaptation to start with) takes the haunted house theme and delves deep into it, creating a psychological horror movie. Perhaps this is one reason why Kubrick is considered an auteur.

Preliminaries

The production team > **Theories and their application** > Directing: The vision

A series of practical **exercises** will help you realise your concept and develop your script

A revealing **interview** with award-winning writer/director Mark Herman concludes each chapter and explores each stage of the film-making process

Chapter navigation helps you find your way around the book easily

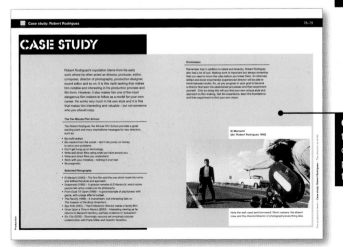

Case studies offer insight into the working methods of some of the world's most successful practitioners as well as new film-makers

How to get the most out of this book

Despite assertions to the contrary by the rest of the crew, the director is the single most important individual in the film-making process. A film is their vision. Even when working with a script written by someone else, it is the director who breathes life into it; who makes it three dimensional.

The director is responsible for what happens on screen, but this is a long and involved process that can take years, often the majority of which is simply trying to get the film underway. The director is a technician, a business person, a member of the audience, an actor, but most of all an artist. It can be the most frustrating of jobs and also the most rewarding. As a first-time director your most detailed experience of film is as a member of the audience. This is useful as it means you consider your audience and know what, for you, makes a good film. However, as a viewer, you have prioritised the illusion of cinema; you have suspended your disbelief. As a director, you must understand every aspect of the long process involved in creating something that will ultimately appear on a 16:9 screen as flickering light.

How to approach this book

Work your way through the book, chapter by chapter, and you will be certain that you are not leaving things out or building in errors that will trip you up later. Problems with films are often the result of directors ignoring first principles or skipping essential parts of the process. Occasionally, this is through over enthusiasm to be deeply involved in the minutiae of other jobs or (at worst) it is from a deep-seated lack of trust for the crew surrounding them.

Screenwriters can make mistakes and cost is no more than a sheet of paper and their own time. It's very different for directors, for whom there are very few second chances.

Not been put off yet? Good, then carry on reading.

All you need to make a movie is a girl and a gun.

Jean-Luc Godard, film-maker

Munich
(dir: Steven Spielberg 2005)

Here we see Steven Spielberg directing *Munich*. When working with actors there is no substitute for clear, effective face-to-face communication.

Introduction

Why short film?

Everybody wants to work in feature film. It is roomier, more glamorous – it's what draws us to film in the first place. However, most great directors have cut their teeth on a short or three. The short film is a calling card. It is cheaper and has fewer logistical complications than a full-length feature. It is what most of you involved in film production education will be undertaking. It is the best way to practise as well as being valid in its own right.

For those wanting to get started in movie making, the short film has some key advantages over the feature. It takes far less time to prepare, can be more experimental and is much more straightforward to make. The relative size of the crew on a short means you get closer to the experience, closer to each of the departments who will help support and realise your vision.

The added advantage of the digital short is cost and distribution. The burgeoning festival scene and the advent of the internet allows you the opportunity to show your work to a worldwide audience.

The film-maker as student

The biggest mistake that budding film-makers make is to think that study is pointless and that as an 'artist' they will be able to make their film from raw talent alone. The best film directors are those who study their art form, either as formal or informal students. The film-making process has changed little since the advent of the medium and with fewer people and smaller budgets, the digital short revolution has arguably brought the process back even closer to where film started. What is evident is that what can be achieved on screen has developed. What constitutes a good story and how you get from that page of text to cinema has not.

As you read this book, practise and study your art. Watch as many movies as possible; read the critics and evaluate their comments; grab a camcorder and experiment with framing shots in different ways; develop your storyboarding skills; read about different theories of directing.

Before you start the process, remember… directing is hard work. The job can be frustrating, exhausting and demoralising. This book is designed to help you make it fascinating, fulfilling and exciting.

Now, let's start planning.

Chapter by chapter

Preliminaries

Chapter 1 sets out the fundamental nature of what a director is before later chapters examine what a director does. In examining these essentials, it also looks at the tricky balancing act of art and business. Telling you how to 'do it' is impossible and thus guidelines and basic principles are established here.

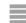

Pre-production

The relative quality of a film is based on the relative quality of the pre-production process. This is usually the longest part of the process. You'll find headings in Chapter 2 that occur later – this is because if you don't start the process here, it will never happen later. This chapter considers cast, crew, finance, art and audience.

Production

This is where it all happens; Chapter 3 is the action movie to Chapter 2's political thriller. This is the part of the process that attracts people to directing. But this is also the part that needs to be quick and efficient. This is the bit that really costs and where there is little room to make mistakes.

Post-production

This chapter covers what happens when the filming has finished; this is where your rushes take shape and start to actually look like a film. In Chapter 4 the complex linking of image to images, image to sound and image and sound to music is considered. This is followed by notes on distribution and exhibition.

The chapters are interspersed with case studies and a linear interview with Mark Herman, director of *The Boy in the Striped Pyjamas*, *Little Voice* and *Brassed Off*.

There is no formula for success. But there is a formula for failure and that is to try to please everybody.

Nicholas Ray, director

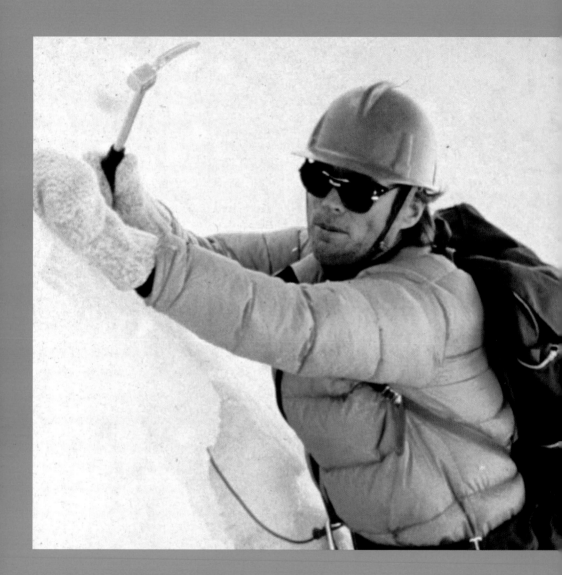

**The Eiger Sanction
(dir: Clint Eastwood 1975)**

We all 'love the movies', and plenty of people say they have a great idea for a movie of their own. However, a director is more than a mere film fan.

The role of the director varies according to the genre of film, the type of script and the requirements of the funder or studio. A short film director is different from a feature director and a director for hire will work differently from a writer/director. However, there are commonalities and it is important to address these similarities before looking at the specifics of each directing context.

The dream of seeing your ideas painted with light on a 16:9 cinema screen, and all the effort you put into making the dream a reality, will mean nothing without the ability to translate and communicate these ideas into your chosen form. Patience, concentration, study and resilience are crucial elements of the director's character and tool box.

Directing a film can seem like climbing the North Face of the Eiger; a hard slog most of the way. You'll feel apprehensive, exhausted, possibly slightly sick from the 'altitude', but the view from the top is well worth it – and you could end up like Clint.

Glossary

Producer: The producer's primary concerns are finance and logistics. At the start of the film-making process they will be responsible for selecting key members of the crew and at the end of the process they will be responsible for distribution.

Film is an artistic medium. Film theorist Ricciotto Canudo called cinema 'the Seventh Art' in 1912, and this tag has stuck. This definition was based on the philosopher Hegel's definition of the six main arts (dance, poetry, music, architecture, sculpture and painting). Canudo was asserting that cinema bridged the temporal and spatial arts.

One major distinction between cinema and the other arts is its reliance on a team of people working together for a single goal. But remember that there is a hierarchy involved in film production, even though it is a collaborative process.

Directors, producers and cash

Cinema has another distinctive feature. It is often more expensive than any other form, although the output of architecture can be pretty pricey too, of course.

While the director holds the main ideas, the **producer** will often work alongside the director. They are the bridge between the business and the art of film. In these terms, their say over cash is crucial. When working on a major feature, they will link with the studio. On a small budget feature or short, they will keep the funder happy – making sure you are meeting their criteria as much as yours. On a lo-to-no budget, they'll make sure you spend next to nothing or nothing at all.

What's needed?

At root, the fiction director is a storyteller who needs:

- People: Your crew is essential. Directing is your job but film-making is a team activity.

- Equipment: At the start, this might be a pen and paper, but later in the process, it is the tools of the trade (cameras, sound equipment, edit facilities and so on).

- Concentration: Film-making can be a protracted and complex process.

- Resilience: Realising an idea can be frustrating and there can be compromises and knock-backs right the way through the process.

- Knowledge: The best directors are the most astute students of their own medium.

And most importantly...

- Vision: A director becomes a great director when they are able to stamp their individuality on a film without stamping it on their crew.

Trusting your vision to the crew

One further distinctive feature of cinema is its reliance on technology. A sculptor may need a chisel, a painter a canvas and oils, but beyond that they are self-sufficient. Given the need for expertise with technology and the need to share the workload both practically and technically, the director needs the production team. For instance:

- Assistant directors: Often responsible for overseeing specific locations or for cueing actors and crew.
- Second-unit director: Often in charge of directing stunt sequences less important sequences or providing coverage.
- Script supervisor: Responsible for liaising between the director of photography (DoP) and the director. They ensure continuity is maintained and on a non-sequential shoot they are essential. They also deal with **slating**, production notes and notes for the editor.

Slating: Slate is used to record a scene number and sync point (via the clapstick) at the beginning of a shot.

Directorial responsibilities

The main responsibilities of the director include:

- Script: Many directors are also writers but even when they are not they have to take words and make them pictures.
- Casting: Finding lead actors, in conjunction with the producer (and on bigger budget films, a casting director).
- Locations: The director will tend to work on the main locations alongside a producer and production designer. These will usually have been pre-selected by a location scout.

- Designing: A director won't have the time to be heavily involved with all aspects of the production, but obviously needs to have a major input into the look of the film.
- Working with actors: Even professional actors need the director to direct.
- Composing: A director works with the DoP to compose shots and provides inspiration for the composer of the soundtrack.
- Editing: It isn't finished until it's in the can.
- Promoting: A film isn't a film unless people see it.

Directing: Art or business? > The production team

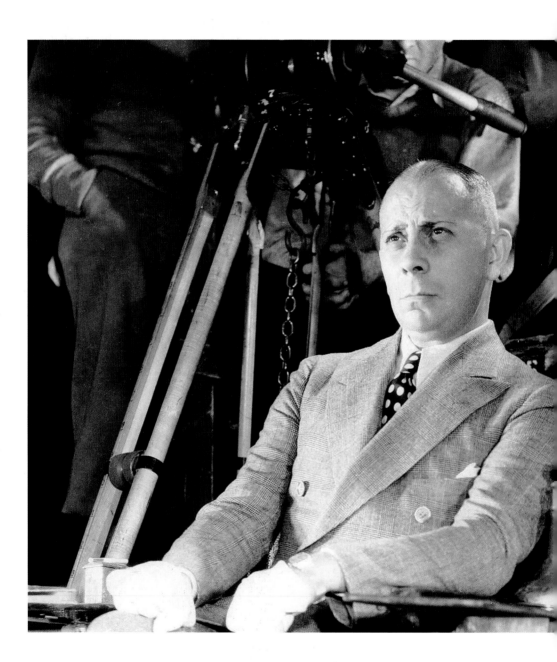

**The Lost Squadron
(dir: George Archainbaud 1932)**

Here Erich Von Stroheim portrays the stereotypical view of the director; a megalomaniac with a megaphone. Remember that shouting instructions may not be as effective as engaging directly with your actors.

The team varies according to the scope, scale and budget of the production. Whether you have a Hollywood team of hundreds or a lo-to-no budget team of eight or nine, it is best to configure your crew in departments. This is not only because it is established practice, it is a system that allows for important roles and responsibilities to be allocated. The importance and involvement of each department changes depending on whether the film is in pre-production, production or post-production. The director is usually the head of the production department.

Negotiating the production team

The film director unites the team. Often this is the most difficult task of all as the crew will make suggestions. These suggestions may be earth shattering. They may provide an insight into the film-making process that has never before been heard. However, they may also not be so great. In fact, you may find yourself amazed at what is being suggested.

Everyone wants to be a part of the process. Some people enjoy the production management roles, but more often than not, everyone wants part of the creative process – and who can blame them? It is, after all, why you are reading this book. Aspects of the creativity required do belong to different individuals, but it is down to you how much input you want and at what point in the process this will occur. This will be outlined in subsequent chapters.

Setting the parameters from the outset is important. You are there to set the artistic parameters and will then need to negotiate in relation to logistical considerations; these logistics then become the producer's concern. Remember that you can never change regulations regarding working practice, health and safety and budget. Telling your producer they must find more money halfway through a shoot will not go down well – nor will it work.

Key people skills include:

- Leadership: Everyone knows you are in charge and you have to act accordingly.
- Vision: Demonstrate the artistic qualities everyone expects.
- Communication: Make your intentions clear but also listen to your team.
- Knowledge: You are a director, know your medium.
- Humility: Admit when you are wrong and acknowledge that other people might know more than you.
- Patience: Film production can be tense; patience certainly is a virtue.
- Humour: Shoots can be long and taxing, keeping things going is a collective effort.

All this amounts to negotiating the inevitable crew dynamics and making the film both your own interpretation and artistic vision and at the same time a collective endeavour.

This is where you need to decide whether you are **Cecil B. DeMille** or not. Do you want to make a film or do you want to be an **auteur**?

> The clouds moving across the road in random patterns, the traffic, what's going on by the roadside – all affect the shot. So you have to think just a little ahead, beyond your mundane self. Why fall back on old habits and other people's ways? Why not trust your eyes and intuition? Why not use taste instead of training? Try to find what best expresses what's going on, what's exciting to your eye. What you end up with might not be 'new', it may not be brilliant, but at least you can say it's you.

Christopher Doyle, cinematographer

Director of photography (DoP)

In charge of the camera/lighting department. The director of photography takes overall responsibility for the look of the film and creates the aesthetic mood.

Director

Composer

Responsible for the musical score. Normally an individual who will compose a score in liaison with the director and after seeing a rough-cut of the film.

Producer

In charge of time and money, the producer is the primary liaison with the studios.

Studios/financiers

Depending on your shoot they may be organisations or individuals. They have a say in what you make, whether you want them to or not.

The production team

Production designer

In charge of the art department. They are responsible for properties, locations, costumes, make-up; in short the whole film aesthetic.

Production sound mixer

In charge of location sound. They record everything that is essential, voices and sound effects. They also make note of any sounds that have to be created in post-production.

Post-production supervisor

In charge of the editing; both sound and vision. The person who works alongside the production team to organise the assembly of images during the shoot; their main responsibility is to piece together the sound and image at the end of the production period.

Whether you are setting out to work on a feature film or on a no-budget short, you will need to assemble the right crew. You need to kick-start the creative process and the organisational dimension of the film and these are the most vital people to do that. The process should always be led by creativity.

Theories and their application

Glossary

Cahiers du Cinéma: (trans. Notebooks on Cinema) A highly influential French film journal founded by André Bazin, amongst others.

Mise-en-scène: The arrangement of scenery and stage properties in a play.

Many established practitioners developed their methods of film-making while effectively being apprentices to other directors. Indeed, most modern film directors continue to be students of their art form. If you want to be a great director you should also want to know everything about your subject.

The auteur theory

The term auteur was once the preserve of film critics and later film-makers. It has now slipped into everyday parlance. While it is a heady theoretical notion, it is also important to understand its practical implications as it may impact on how you behave before, during and after a shoot.

The concept of the 'auteur' frames the film's director as being in sole creative control of the film. In these terms, a film is the director's personal creative vision. The main proponent of the theory was the film director and critic François Truffaut in the influential journal ***Cahiers du Cinéma***.

This almost literary approach to the authorship of cinema prioritised the writer-director, who retained the majority of creative control, but subjugated the role of the screenwriter. It meant that, in the same way that a literary critic could examine a writer's approach across a series of novels – a film critic could follow a director's traits across a range of films. This could be a visual style (Tim Burton) or a thematic link (Shane Meadows).

This theory has been so prevalent, alongside the inevitable prioritisation of the role of the director in any production, that it has been seen to have a limited theoretical use and a negative practical one.

Preliminaries

The parameters of meaning

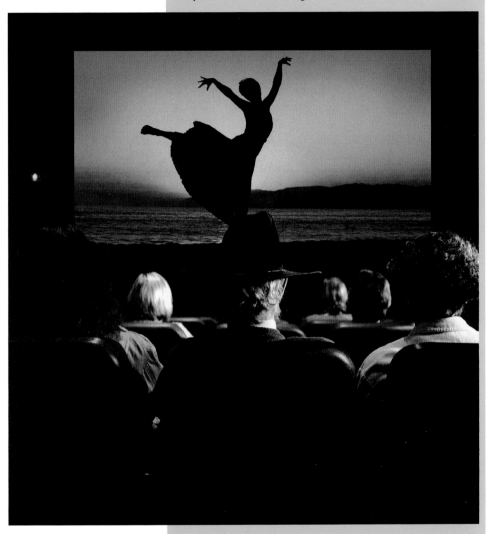

All the theories of authorship aside, there is one very important thing that practitioners should understand. Whatever you might have meant, whatever was going through your mind, whatever you noted down or discussed with your crew, when the projector rolls, an audience will only have flickering light on a screen. Meaning is generated between the person sat in the darkened room and the screen. The potential for different interpretation is huge. All you can present are parameters, the edges of the screen, the **_mise-en-scène_**. It follows that one of the most important facets of the director's role is precision. But as always, this is more complex than it sounds.

Glossary

Christian Metz: (1931–1993) French film theorist and semiotician. His book *Film Language: A Semiotics of the Cinema* was hugely successful in examining film structure.

Christian Metz and film language

One of the most renowned film critics is **Christian Metz** and of particular importance is his book *Film Language: A Semiotics of the Cinema*. In this book Metz provides tools for analysing films down to the smallest detail. Metz breaks down the act of filmic communication into five channels:

1. The visual image
2. Print and other graphics
3. Speech
4. Music
5. Sound effects

What Metz's list suggests is that an audience prioritises the visual image. The danger is that so does the director, but the power of the other four channels of communication is vital. The complexity of film is in the interaction of these channels. Meaning is generated in the intersection of all these.

Each member of a film crew has jobs that look at these aspects in isolation. It is your job as director to unite them. You must also be able to communicate this holistic vision. This might seem straightforward when you have a script to follow, but as Chapter 2 shows, that only gives you the bare bones to work to.

Metz was concerned with breaking cinema down into its smallest elements to establish how meaning was being communicated to an audience: this is why his work is of such importance to new directors. His work developed from linguistics and it is useful to bear this focus on a structured sequence in mind. As Metz said: 'Cinema begins with the sequence of images; it is above all by the ordering of these images that cinema can organise itself into a discourse.' With the term 'discourse', Metz suggests that this is where film starts to generate meaning; and therefore has a social purpose.

A film is difficult to explain because it is easy to understand.

Christian Metz, film critic and theorist

**The Shining
(dir: Stanley Kubrick 1980)**

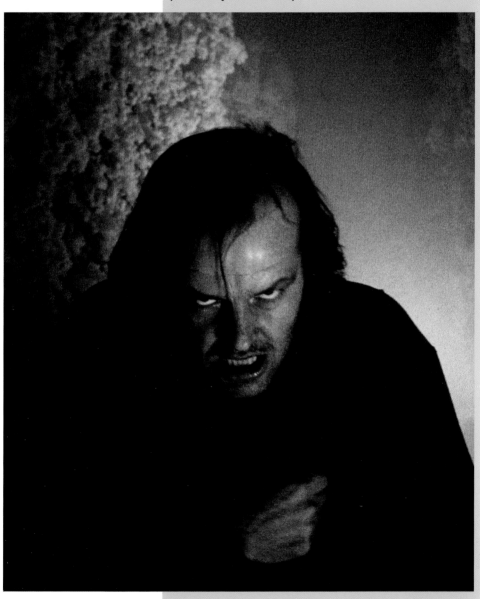

With *The Shining,* Stanley Kubrick showed that you can make a
genre piece that develops the genre and also does something which
is unique. *The Shining* (an adaptation to start with) takes the haunted
house theme and delves deep into it, creating a psychological horror
movie. Perhaps this is one reason why Kubrick is considered an auteur.

Glossary

Semiotics: The name given to a body of theories that examine the nature of textual communication by breaking down the 'text' to its smallest elements and their combination.

Genre: The name given to the characteristics, stories and/or aesthetics that link films (often of different countries and different periods).

Semiotics

Semiotics is a branch of the theoretical and philosophical area known as structuralism. It is based on the linguistics of Ferdinand de Saussure (1857–1913). This seemingly tangential basis to the theory is particularly relevant as later proponents (like Metz) talk in terms of a cinematic 'language'. Like all languages, we need to know all the words, nuances and accents in order to communicate clearly.

There are many other theorists of note who are also worth examining, such as Roland Barthes, Claude Lévi-Strauss and Umberto Eco.

There are many concepts associated with semiotics, but by far the most important is the relationship between the signifier and signified – the sign. The signifier is the physical form of the sign; the image on the screen or the sound that we hear. The signified is the mental image the individual audience member takes from this. Meaning in the form of the sign (the amalgam of the signifier and signified) exists in the mind of the audience member. The problematic dimension of this is that it doesn't necessarily point to the *mise-en-scène*. Instead it points to all the isolated elements within the *mise-en-scène* plus the sound and how these things operate together.

The usefulness of this theory is in emphasising the importance of precision. Each individual element has to be right. Think of a frame as a sentence, a scene as a paragraph and a film as novel. Change a few words here and there and the meaning can be radically changed.

This awareness is crucial when your own location, the light is going and you have two more scenes to film with no hope of a reshoot. You need to bear in mind that any snap decision still has to fit within the language of film and the 'novel' you are constructing. Many directors talk about happy accidents, where something happens on set that just seems to 'fit', but the skilled director will know what works and what doesn't because they are versed in their own art. They are fully aware of the nature of their own work, how it should communicate meaning and, ultimately, what that meaning should be.

Genre

Much has been written about **genre** and it is worth familiarising yourself with the codes and conventions of as many genres as possible. Whether it be thrillers, westerns, film noir or farce; as an audience we know genres when we see them, as we are so well versed with cinema. The importance for a director is to know them and to be able to use them when you need to.

Genres are established over time and are used for a multitude of reasons. A key reason is that audiences are familiar with genres and their look and structure. They can be limiting but they can also provide you with a vocabulary you can use, as with Clint Eastwood's revisionist western *Unforgiven* (1992). These films use particular periods in history, particular narrative structures and character types; the anti-hero, the hero and the gun fight.

Film companies like genres because they provide a marketing tool and build audience expectations. For film-makers (not just directors), they provide structure and a springboard to develop something new.

The genre may be fixed by the studio or by the script, but how this is played out on screen is down to the director. However it is used, the conventions of genre are another mode of signification and your audience will expect something of it.

Film needs theory like it needs a scratch on the negative.

Alan Parker, director, writer, actor and producer

**Manhattan
(dir: Woody Allen 1979)**

Manhattan is Woody Allen's eulogy to the city. While he is concerned with the vistas he is also interested in the people; those who live in Manhattan exist on the edges of the screen. The protection of the *mise-en-scène* was so important to Allen that *Manhattan* was released in its original cinema format on VHS rather than the usual 4:3 cropped-for-TV version.

Glossary

Narrative: The art of structured communication. Narrative is often used in the same way as story but is also about how the detail of the story is structured, communicates and thus has meaning to an audience.

Directorial vision is a difficult thing to pin down in words. It is difficult to define and almost impossible to teach.

It is the aspect of the film-making process that might be defined as the 'X' factor. However, there are things that you need to consider as you develop your own style.

It is also worth remembering that many directors work 'for hire' and, while they bring something of their own style to a film, they are fitting into a format dictated by the studios. An examination of the *Harry Potter* series of films is a good lesson in this. All the directors that have been employed are highly skilled auteurs, but the films look and feel very similar. It is this ability to move between individual expression and formula that can be the mark of a talented and bankable director.

What makes a 'good' film?

- Context: Make sure you are aware of what you are making.

- Genre: Nothing exists without generic reference.

- References: The best film-makers are often the best students of their own medium.

- Communication: You need to get your ideas across to the team that will assist you.

- Trust: Allow and encourage others to aid you with advice or with their own skill.

- Perseverance: It takes time and effort to get your film made.

- Tenacity: Keep going even when things look lost, without compromising your ideas.

- Compromise: You might not be able to get the helicopter shot on a minuscule budget. Consider what you can do to maintain the quality of the film.

- Integrity: Humility is important but so is integrity. If you genuinely believe in your ideas, so will other people.

- Skill: This comes with practise.

The directors who make the biggest mark manage to do something new, even when basing their work on the films of others.

**Flapwing and The Last Work of Ezekiel Crumb
(dir: Alasdair Beckett-King 2006)**

Flapwing is a film that draws on a range of sources, both filmic and cultural. There are traces of Tim Burton and traces of Stanley Kubrick. There are also references to J. Robert Oppenheimer, who helped to invent the atomic bomb, and his famous use of the quote from the *Bhagavad Gita* 'Now I am become Death, the Destroyer of Worlds.' But despite the references, this film is unique in its **narrative**, imagery and storytelling qualities.

Glossary

Subplots: Narratives that are often tangential to the main plot but which are used to elaborate on character and events. Sometimes called the 'B' story.

The writer/director

The advantages of being a writer/director are fairly self-evident – comprehensive and holistic artistic control over the story and the finished product. Many directors maintain control in this way. However, just as many well-established and critically acclaimed directors prefer to work on scripts written by others; for instance, Spielberg has writing credits on only seven of the films he has been involved in but no one would question his stature as a director. Others, such as Jim Jarmusch and Mark Herman, only direct their own scripts.

A key skill to develop is the interpretation of a script. For new directors who work on their own scripts, it is often difficult to understand how certain concepts or instructions can be misinterpreted by your crew. If you can see it why can't everyone else? It is therefore good practice to realise the scripts generated by other writers. In this way, it is possible to see what it takes to move a script to the screen and where confusion may arise. If you intend to work on your own scripts to start with, take a script for a major film and see what happened in the process of translation to the screen. The script is a template for the director, but also for the heads of department and the actors. In this sense, it has to be produced in a particular way. Research screenwriting in the same way you are directing.

Advantages and disadvantages aside, in the low-budget film market the writer and director are usually one and the same. This is why starting with a short film is a good idea.

Why make a short film?

Most people want to rush into features. However, a low-budget feature will always look low budget and they are rarely successful. There are always exceptions, such as Robert Rodriguez and Peter Jackson, but they are exceptions to the rule. The advantages to making short films in the first instance are manifold.

Some main reasons for starting with shorts are:
• They are cheaper and therefore the risks are lower.
• They use fewer crew.
• They are usually logistically simpler.
• They usually deal with fewer characters.
• Distribution is less complicated.
• They are the calling card for many new directors.
• You can make shorts while you develop your feature.

Feature film stories are also more complex in their scope and outlook. They often deal with multiple characters and **subplots**. Learn to deal with directing a couple of actors and the logistics of a 10-day shoot before dealing with a large cast and a 10-week shoot.

The difference between features and shorts

In the majority of cases feature films:

- Are much longer than shorts – this sounds obvious but the increase in complexity is exponential.

- Deal with a larger number of main actors and extras as there are usually more characters.

- Have more than one storyline – subplots or minor storylines increase complexity for you, your actors and crew.

- Cost more because it takes longer and often involves more locations.

- Are controlled by studios or funders and you have to take account of their wishes.

- Deal with in-depth characterisation, requiring more of you and your actors.

- Deal with closure, which has to be satisfying for the audience.

There are always exceptions to the rule and examining a film such as *12 Angry Men* (dir: Sidney Lumet 1957) will be a great lesson in combining simplicity of location with complexity of plot and direction.

Short films tend to be:

- Much shorter, with festivals dictating the length – aim for 10 minutes as a guide.

- Freer in structure – but this means an equivalent amount of planning as a feature.

- Based around recognisable character types. However you still need to direct your actors and provide them with the information they need.

- Can be open ended, but this is only for the audience; you need to know the story and how it might end.

- Based around a smaller number of characters and settings.

- Cheaper, due to scale and numbers of actors and locations, but costs are still involved.

- Less constrained, as they are normally intended for a small festival audience.

- A great testing ground for new talent and your opportunity to shine.

For a film that epitomises all that narrative shorts can achieve, examine *The Shovel* (dir: Nick Childs 2006) which won awards at the Tribeca, Woodstock and Woods Hole film festivals.

**An Alan Smithee Film: Burn Hollywood Burn
(dir: Arthur Hiller and Alan Smithee 1997)**

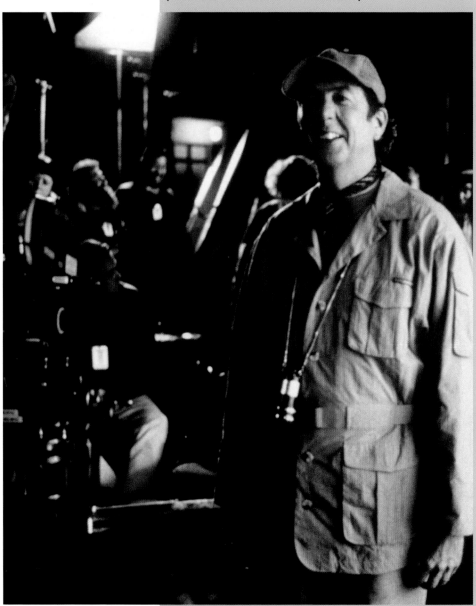

The premise of this film is simple. A director wants to remove his connection to a film, but his name is Alan Smithee. This film was written by the noted screenwriter Joe Eszterhas and directed by the noted director Arthur Hiller. Hiller credited the film to Smithee.

Alan Smithee is one of the most important individuals in film-making. He has reputedly made more than 50 features, music videos and television programmes. This is no mean feat considering he started in 1969 – and he doesn't exist.

Alan Smithee is the name given to a director when they wish to disassociate themselves from their work. More often than not, Smithee is called upon when a film is re-cut by a studio, often for video release, TV release or for a lower rating. It is sometimes when a studio dislikes an ending (often after test screenings) and insists on a re-shoot.

Whatever the reason, this is where a director loses his or her name on the credits and all the work is lost. This is most common in major studio productions rather than the low-budget end of the market, but even with small productions the number of tantrums is remarkable. In many ways, the whole purpose of this book is to help you avoid Alan Smithee. So try the tips on negotiating with the production team mentioned earlier in the chapter and follow the established processes outlined in Chapters 2, 3 and 4 as well as Mark Herman's advice in each chapter. If none of that works, you can always call on Alan.

Glossary

Alan Smithee: The name used by directors on credits when they no longer wish to be associated with a film.

Notable films 'directed' by Alan Smithee

- *Death of a Gunfighter* (1969)
- *The Barking Dog* (1978)
- *Appointment with Fear* (1985)
- *Ghost Fever* (1987)
- *Catchfire* (1990)
- *Hellraiser: Bloodline* (1996)
- *An Alan Smithee Film: Burn Hollywood Burn* (1997)
- *Wadd: The Life and Time of John C. Holmes* (1998)
- *Beach Cops* (2008)

EXERCISES

The best thing you can do in beginning your career as a director is to build your knowledge about your own subject.

1
Choose a film that is considered a classic, it doesn't matter if you don't like the film. What is it about the film that has led it to gain its reputation? This should be repeated across a range of 'classic' films. Try to establish if there are any patterns, any similarities; or is their status down to the unique qualities of each individual film.

2
Choose a cult film. These films have an inherent sense of 'cool' and are appeal to new directors. Repeat with a range of cult films. What is it that makes them worthy of this status, or is it something that is determined by an audience and critics?

3
Take a 10-minute section of a film (openings are good) and view it with the sound muted. What is it about the construction of the shots that is of note? What do the music and the sound add? Next take the text for a stage play. How would you translate it to a film? Stage plays are notoriously wordy and visually limited. You will have to add a visual aspect to the text.

4
Watch a film in a different language without the subtitles. Can you still discern meaning? If so, how?

5

Take a famous director and look at a piece of their work that is firmly within a genre (such as Ridley Scott's *Alien*). Compare it with other lesser work from the genre. What is it that the well-known director does that makes the film stand out?

6

Connect with local film-makers. There are film-makers in all towns and cities around the world. Join a film society. If you can't find one, start one. Try and get to a film festival. Don't worry if it is a small or amateur festival.

7

Get hold of a camera, even a stills camera, and start looking at the world through a lens.

8

Begin a project. It doesn't matter how small or what equipment you use but the process outlined in Chapters 2, 3 and 4 is best worked through in relation to something real and something specific to you.

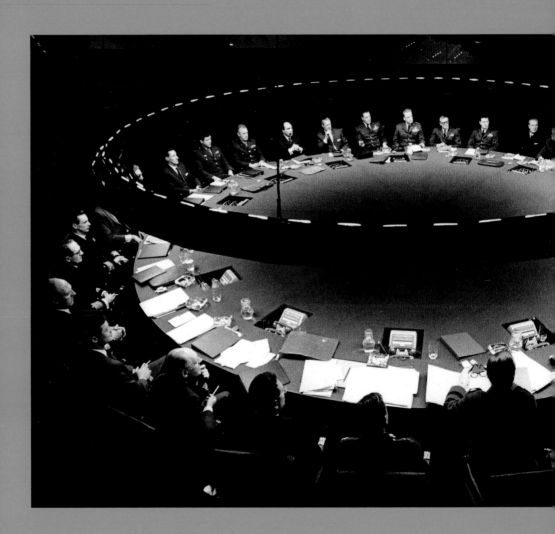

PRE-PRODUCTION

**Dr Strangelove or: How
I Stopped Worrying and
Learned to Love the Bomb
(dir: Stanley Kubrick 1964)**

Pre-production is normally the longest part of the film-making process; it is also often the part that is least attractive to a new film-maker. However, the process of pre-production is vital if you are going to make an effective film.

We all know about the importance of planning in all aspects of life – and film is no different. For you as director, this planning can be broken into two sections; logistical and conceptual. It would be all too easy to give the logistical aspects of the process over to the production team without consideration of how the logistics impact on the concept and vice versa. This highlights the importance of communication and delegation. Without a strong concept the film will not work – this is why the director remains in charge throughout the whole process.

Assuming your producer has secured funding, you are ready to go. If they haven't, get them on the case, you need to be ready to film by the end of this chapter.

A film production could easily feel like the war room in *Dr Strangelove* if you try to involve everyone in the decision-making process. When possible just deal with your heads of department and let them manage their teams.

The pre-production team encompasses many of the roles that feature throughout the production process. The key thing with pre-production is to decide who should take the lead on the various aspects of production that require development – and when they should get started. As outlined in Chapter 1, the heads of department will work with the director and producer, but they will also start to employ other crew who will also have some input into development.

Shared vision

As will become clear, there is some crossover in the team as your film moves into production and then into post-production. There is always a hierarchy involved in production; otherwise decisions would never be made. However, this hierarchy shouldn't stop you from discussing and debating creative issues. After all you are working on the film together. Discussions are a good way to get your team to bond and can be very valuable, especially in a low-budget film context where the crew may be offering their services for free and need to feel fully invested in the project.

With any form of discussion, the trick is to listen and evaluate what you hear. Someone else may come up with a great idea and should be credited for it. Remember that you are always in creative control. As you get closer to production, this discussion needs to move to clear decision making and much of that is down to you.

Sharing the creative vision is essential. If you suspect your crew has differing views of how the film will look and feel it can be useful to ask them to bring examples of films that support their view and share them. Iron out any problems at this stage.

Remember that in the low-budget short film, field members of the crew may have to adopt more than one role. This shouldn't stop you making sure everyone sticks to the specifics of their role (even if they are assuming more than one); this means you can focus on yours.

There is a sort of creative purity in an independent film, in the passion of the director, the passion of the crew. They're not getting a whole lot of money, so you know they are not there because they want to get rich. Instead, they are there because they want to make a movie. In the bigger films… it's just a job for a lot of people, so there is less of an intense energy devoted to the whole project.

Amy Irving, actress

Pre-production

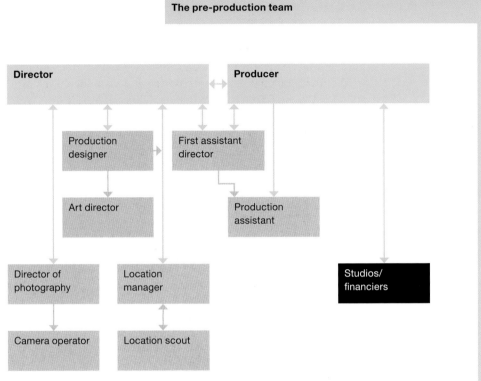

The pre-production team

Director ↔ Producer

- Director
 - Production designer
 - Art director
 - First assistant director
 - Production assistant
 - Director of photography
 - Camera operator
 - Location manager
 - Location scout
- Producer
 - Studios/financiers

You should know who the main members of your crew are before starting the detailed process of pre-production. In many ways, this stage of the process can be the most fraught and it is therefore now that you require the most support.

The script forms the basis of film. Without it, film does not exist. As a director you need to learn how to work with script. This sounds easier than it is. Not only do you have to learn how it works, you need to interpret it for yourself and communicate this to your cast and crew. You are making visual what is essentially a piece of literature.

Breaking down the script

When a director initially considers a script, they do so, first and foremost, as an analyst. This initial analysis cannot be conducted quickly or easily. It is something to which you need to devote time and energy. It is only through this process that the script can develop into something from which you can make a film.

The initial analysis is the first point where the film is 'made' by you. This is where your creative input comes in and where interpretation begins. There is a sense in which the script will change constantly during the process of film production, due to external constraints and events, however all changes will be in relation to the central core meaning. That meaning is what you need to impose at this early stage.

Script considerations

Structure is central to any script and any film. It is therefore important to consider the following:

- Who are the characters? You'll need to work on a back story for each.

- Are the characters characterised correctly?

- Is the tone of delivery of speech clear?

- Do the physical descriptions of characters work? If these descriptions don't exist you'll need to create them.

- Are settings/locations fully explained and explored?

- Are there any subtexts that you need to explore or draw out?

- What is the central theme or meaning? Does this recur?

- What is the cause-and-effect relationship between events?

- Do the scene transitions work effectively?

- What is the plot?

Make sure you take account of the house-of-cards effect; once you make one change, the rest of the script could go with it.

The writer

The question of when to involve the writer is a difficult one and is really dictated by the relationship you have with the writer. More often than not a director will interpret the script and then request the writer to make the suggested changes. The director usually avoids making changes themselves to ensure consistency of tone.

If you find yourself having to make major revisions to a script you should question whether it is the right script in the first place.

The script editor

Being a writer/director can be dangerous if you are new to directing. You need to consider the issues associated with trying to interpret something you know well and communicating this to your cast and crew. However, most low-budget directors (and many feature directors) are also the writers of their work. A sense of objectivity is useful and this can often be achieved through consultation with a script editor. Another useful technique, even if you plan to direct your own scripts, is taking scripts by others and working through the script considerations opposite to hone your development and communication skills.

As a writer, you have control of the words you put on the page. But once that manuscript leaves your hand, you give control to the reader. As a director, you are limited by everything: weather, budget, and egos.

Nicholas Meyer, film writer, producer, director and novelist

A clean page of script

Keith enters. Christine is in bed with Richard. They both
sit up gobsmacked. Keith is utterly stunned.

He drops the teacup, we follow its fall in slo-mo. As it
hits and splashes we go straight to a violent flash of white
light

ON WHITE

INT. A ROOM. DAY.

It's white and details resolve out of it. A snow white
tablecloth. A silver tray with tea things laid on it. A
white teapot, a white milk jug, a beautiful and capacious
white china cup on a white saucer. The scene has a slightly
surreal burnish to it.

A MAN, grave and dignified, looking like high grade butler
and wearing white gloves picks up the teapot and pours.
A golden stream of tea arcs into the cup. Then he pours the
milk and passes the cup to Keith. Keith is framed against a
white background.

 BUTLER

 There you go, Mr. Underwood

 a nice cup of tea

Keith picks up the cup, studies the colour, inhales the
aroma. Then, tentative, takes a sip. It is a beautiful cup
of tea. Perfect. He gives a beatific smile. He nods
slightly. The Man acknowledges his nod with a satisfied,
duty done nod of his own

Keith drinks the tea. He puts the cup down. Smiles

He stands. Instantly two **UNIFORMED MEN** move in on both sides
and pinion his arms behind his back

The folded hankerchief that the MAN whips out of his front
pocket is a **HOOD**

And a door to the side to the side of the table swings open.
Revealing the **GALLOWS**

FAST FADE TO BLACK

SFX - Trapdoor crashes open

MUSIC: I Like a Nice Cup of Tea - **TITLES**

Working with script is a skill to be developed. You need to pay
careful attention to what is there, but also what isn't. The script is
a structure and a framework; it needs you to make it into a film. This
includes fleshing out the scene descriptions and adding a visual
sense to dialogue.

Hand-marked script

CONTINUED (22)

(WS) Keith enters. // Christine is in bed with Richard. They both } CUT
(MS) sit up gobsmacked. // Keith is utterly stunned. } BETWEEN

(CU) He drops the teacup, we follow its fall in slo-mo. As it
hits and splashes we go straight to a violent flash of white
light CLOSE UP ON THE CUP – FOLLOW IT DOWN

[CUT **ON WHITE** ?] TO DRAMATIC END – LIQUID SPLASHING.

(23) INT. A ROOM. DAY.

It's white and details resolve out of it. A snow white ⎤
tablecloth. A silver tray with tea things laid on it. A ⎟ Dream
white teapot, a white milk jug, a beautiful and capacious ⎟ like
white china cup on a white saucer. The scene has a slightly ⎟
surreal burnish to it. ⎦

(WS) A MAN, grave and dignified, looking like high grade butler
and wearing white gloves picks up the teapot and pours. //
(CU A golden stream of tea arcs into the cup. Then he pours the
TEAPOT) milk and passes the cup to Keith. Keith is framed against a
white background. (WS)

 BUTLER
METAPHOR : DELIVERY – TRADITIONAL BUTLER
ENTERING There you go, Mr. Underwood LOOK AND VOICE
HEAVEN
 a nice cup of tea VERY DEFINED .

Keith picks up the cup, studies the colour, inhales the
aroma. Then, tentative, takes a sip. It is a beautiful cup
of tea. Perfect // He gives a beatific smile. He nods
slightly. The Man acknowledges his nod with a satisfied,
duty done nod of his own
 └ (WS) – TWO – BOTH OF THEM .
Keith drinks the tea. He puts the cup down. Smiles

(MS) He stands. Instantly two **UNIFORMED MEN** move in on both sides
NEED TO and pinion his arms behind his back
SEE NON-
SPECIFIC The folded hankerchief that the MAN whips out of his front
UNIFORMS pocket is a **HOOD** (WS) -- WE REVEAL PRISON GUARDS

And a door to the side to the side of the table swings open.
Revealing the **GALLOWS** PAN ?

FAST FADE TO BLACK

(24) SFX – Trapdoor crashes open

(25) MUSIC: I Like a Nice Cup of Tea - **TITLES** MUSIC: NICE
 CUP OF TEA .

FIN

The first stage is to mark the script by hand. Even with the various
pieces of software available for this mark-up, it is still important to
give careful consideration before you start work – simply taking time
to think it through can make the formalising of the shooting script a
lot clearer and more accurate.

Formal shooting script

CONTINUED 22. (1)

WIDE SHOT DOORWAY Keith enters.

MID-SHOT BED - Christine is in bed with Richard. They both sit up gobsmacked.

MID-SHOT Keith is utterly stunned.

CLOSE UP He drops the teacup, we follow its fall in slo-mo. As it hits and splashes we go straight to a violent flash of white light

CUT ON WHITE

23. INT. A ROOM. DAY.

It's white and details resolve out of it. A snow white tablecloth. A silver tray with tea things laid on it. A white teapot, a white milk jug, a beautiful and capacious white china cup on a white saucer. The scene has a slightly surreal burnish to it.

WIDE SHOT DOORWAY - A MAN, grave and dignified, looking like high grade butler and wearing white gloves picks up the teapot and pours.
CLOSE ON THE TEAPOT A golden stream of tea arcs into the cup. Then he pours the milk and
WIDE SHOT passes the cup to Keith. Keith is framed against a white background.

 BUTLER
 (Refined Voice)
 There you go, Mr. Underwood
 a nice cup of tea

Keith picks up the cup, studies the colour, inhales the aroma. Then, tentative, takes a sip. It is a beautiful cup of tea. Perfect.
CLOSE ON KEITH He gives a beatific smile. He nods slightly.
WIDE SHOT The Man acknowledges his nod with a satisfied, duty done nod of his own

WIDE SHOT Keith drinks the tea. He puts the cup down. Smiles

MID SHOT (TORSO - SEE THE UNIFORMS BUT NOT THE MEN) He stands. Instantly two **UNIFORMED MEN** move in on both sides and pinion his arms behind his back

WIDE SHOT The folded handkerchief that the MAN whips out of his front pocket is a **HOOD**

And a door to the side to the side of the table swings open. Revealing the **GALLOWS**

FAST FADE TO BLACK

24. SFX - Trapdoor crashes open

25. MUSIC: I Like a Nice Cup of Tea - **TITLES**

 THE END

This is the final version of the script that you will present to your crew. To avoid confusion, any further revisions to the script must follow industry-established conventions.

The shooting script

A **shooting script** is what you provide for the crew. If you are a writer/director you will have already written the script, but now you need to format it as a shooting script. This process of development is an important one as it allows departments to work with the same document throughout the process.

Like the formatting of a script for a screenwriter, the following conventions are industry established and should be followed without question – they are there for a reason.

- When a script is presented as a final draft there are no further amendments to the page numbers. This is to ensure consistency.
- Use a header with the date and script reference on it.
- Scenes are numbered alongside the headers.
- (CONTINUED) or (CONT...) is used at the bottom of a page where dialogue or a scene continues over to the next page.

Glossary

Shooting script: The version of the script prepared for the crew to work from to ensure consistency and accuracy.

Revisions

Making clear revisions ensures consistency.

Pages:

- When amendments are made (and they often are) you need to produce these on revision pages. These are additional sheets. This may seem over the top for a nine-page script but it is very easy to slip between versions with catastrophic effects later in the shoot. You also save paper by not re-printing everything.

- If your changes move beyond a single page then they begin to be marked A, B, etc.

- If you delete a page of script then issue a blank page with 'DELETED' or 'OMITTED' on it, otherwise that rogue page might stay there in error.

- When you issue revisions, it is convention to do so on different coloured paper each time to give a quick visual clue. A date stamp is also useful. On a very low-budget shoot you can always mark the paper edge with a different colour.

- When a line is changed, it is worth noting it with an asterisk in the far right. This is very helpful for actors and script supervisors who need to be word perfect.

Scenes:

- When a scene is added, do not change the scene numbers – again use A, B, C...

- If a scene is removed mark it as 'DELETED' or 'OMITTED' and never reuse the scene number.

CASE STUDY

Peter Hunt

Peter hunt is the writer, director and producer of *Elevator Gods*. This is his first feature and it has been in development for four years. Peter directed, wrote and edited the *Elevator Gods* promotional trailer, which can be seen on www.happyourfilms.com.

Elevator Gods and the process of pre-production

Peter Hunt has detailed knowledge of film production and has worked in the film industry in a number of contexts. However, the development of *Elevator Gods* and the time it has spent in pre-production is an example of the complexities of film-making and the tenacity required in developing a film. As Peter explains himself, it's a complex process:

'I'm from a graphic design background, and I packaged the script to look really good. That was four years ago. People fell in love with the premise, but the script always needed work. In 2009, it's hopefully now working, four years after the initial conception. The difficult parts of the development have been trying to learn the craft of directing (if I stay on board as director), trying to speak the same language as experienced heads of department, and raising the finance. I was lucky enough to experience a dry run of pre-production of *Elevator Gods*. We planned to shoot in 2007 but rescheduled because of music clearance and casting issues.

'The finance has been raised by a combination of my own cash and other funders. They recognised my commitment and determination to tell a story that was truthful and marketable, which overshadowed my relative inexperience.

'At this point in the pre-production process sets have been built, equipment purchased and borrowed, the team has been assembled, and casting has been done (which has been central to the next script polish – draft 23). We've also begun 'workshopping' with the actors and editing together the workshops.

'The next stage is negotiating music rights and offering the music publishers an incentive to give us a good deal (explaining how the music will be used and who is attached to the project). Scheduling is something that it's not in my best interest to worry about if I can help it – that's the job of a full-time line producer.'

Conclusion

Elevator Gods exemplifies the fact that no matter how much
you prepare there will always be things outside your control
that impinge on your production. The film is now about to start
production and Peter Hunt demonstrates two essential attributes
of the budding low-budget feature director; tenacity and drive.
These are two vital qualities that you must cultivate as you
progress in your film-making career.

**Elevator Gods – teaser trailer
(dir: Peter Hunt 2006)**

Peter made a teaser trailer to show the mood and feel of the film.
This was intended to attract possible funding, and also crew who
could see the visual quality of the work without having to read a
feature film script.

Glossary

Connote: (of a word) Imply or suggest a feeling or idea in addition to its primary or literal meaning.

The composition of the image is all too often forgotten until the shoot itself. Your crew should have scheduled for set-ups, a run through and whatever ratio you are working for shooting. However, they will not have set aside time for you to hang around on set and think of the shots you need, because suddenly what you've drawn on your storyboard doesn't make sense in terms of communicating meaning. You need to know how different shots will **connote** meaning from the start.

The shots you plan for are not just images that look good – they also need to deliver meaning. The famous quote from Charlie Chaplin that 'life is a tragedy when seen in close-up but a comedy in long-shot' is glib but is closer to the truth than it may at first appear.

Different kinds of shot

By moving the camera, or zooming, it is very easy to change the way your shots will look. Different kinds of shot will have a different effect on people watching the film. You should always think about the kind of shot you want before you begin filming.

There is much you can do with image composition that will connote meaning to an audience. Much of this depends on whether you are shooting a face, faces, scenery or action, or all of them at once.

It is often better to consider the individual shots before considering the style of filming. This ensures that you don't compromise the emotion and meaning of the scene.

Different shots

1.

2.

3.

4.

1. Wide
The first shot in a scene is often a wide. This helps show the audience where the action is happening.

2. Full length
This kind of shot is often used for comic effect. If a character is wearing a costume or dancing in a silly way, a full-length shot could be used to show this.

3. Mid shot
A mid shot shows a character's head and shoulders. Characters are often framed like this when they talk to each other.

4. Close-up
A close-up can be used to show a character's feelings. If they are sad, a close-up will help the audience to feel sad. If they are angry, a close-up could make the audience scared.

Considering mood

While the individual shots are the bare bones of your composition you also need to consider the impact of light. This is most evident in something like film noir, where the genre is defined partially by the use of light. A common misconception is that this will be determined by the director of photography (DoP) rather than being constructed in liaison with the DoP. No matter when you integrate the DoP into the schedule, you still need to know what mood you are trying to create.

It is easy to forget that film is two dimensional, but has to appear to be much more than moving images. Careful composition takes you away from this. The creation of depth is vital, as can be seen in the still from *Battleship Potemkin* shown opposite. The steps, with the soldiers at the top, provide a vital sense of depth and perspective that is particularly crucial to a wide shot like this.

It is also important to remember that your camera doesn't have to remain static. The use of a dolly (tracks) or a Steadicam can really benefit the overall image composition. In these terms, the image composition changes subtly throughout a scene. It is worth going back to a film to look for this kind of camera movement. There are many instances of effective Steadicam work in a variety of films, for instance examine the work of Vince McGahon in Tim Burton's *Sweeney Todd: The Demon Barber of Fleet Street (2007).* When used correctly, the gradual change in composition created by the moving viewpoint adds to the scene without being explicitly noticed by the audience.

You must find the note, the correct key, for your story. If you find it, everything will work. If you do not, everything will stick out like elbows.

Louis Malle, director

**Battleship Potemkin
(dir: Sergei M. Eisenstein 1925)**

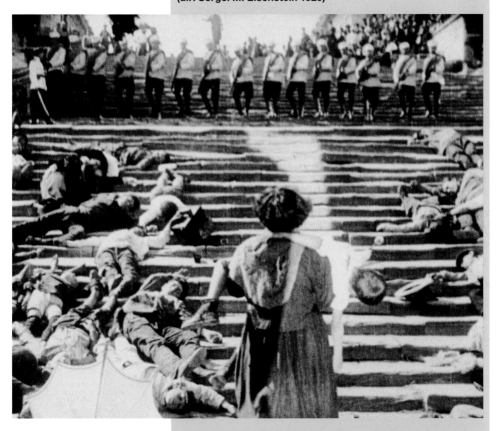

The classic *Battleship Potemkin* has been copied and parodied many times, however it remains a remarkably powerful film. Viewing silent film can be a valuable lesson in how to construct an image. In this scene, the threat of the soldiers is enhanced by the position of the camera at the bottom of the steps. The camera remains static as the soldiers move ever closer.

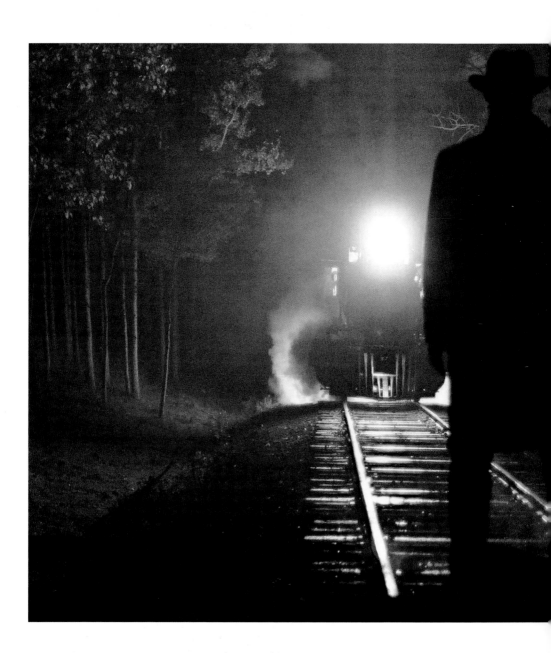

The Assassination of Jesse James by the Coward Robert Ford (dir: Andrew Dominik 2007)

This image demonstrates the importance of light and shadow in creating mood. Up to this point the film is light and faces are clearly shown as characters are established. This classic image of the figure in silhouette creates menace and threat. The robbery and chaos that ensues is enhanced by this stark *mise-en-scène*.

Glossary

Storyboard: The visual representation of the shots, often with accompanying contextual and relevant shots and text.

A **storyboard** is one of the most vital tools used in the pre-production process. It is the foundation for communicating the visual and narrative progression of your film.

Many budding film-makers are reluctant to put pencil to paper because of their perceived lack of artistic ability. Remember that a storyboard doesn't need to be beautiful; it just has to be understood. If you find it difficult to draw well, use stick people and arrows. If you know the locations that will be used, you could try taking digital photos and drawing on top of them. There are many pieces of software that will allow you to generate storyboards. These are potentially useful, but be careful not to get too wrapped up in playing with the technology rather than doing what you are supposed to be doing – an easy trap! Some software also limits you to a small range of images and scenarios.

Some directors, including people such as the Coen Brothers and Terry Gilliam, will storyboard every scene. Others only use them for intricate scenes. Some claim never to storyboard. Where no storyboard exists, an alternative tool needs to be present. You need to be particularly skilled in other ways to work without a storyboard, and to dispense with them is extremely dangerous for new directors.

Storyboard templates

Storyboard templates vary dramatically and in many ways you can find your own that works for you. The simplest storyboards are purely visual, however it can also be very useful to include lines of dialogue beneath each image. This is particularly useful when dealing with voiceover to ensure a match of image to voice.

A note of caution: While storyboards are highly recommended it is important not to become a slave to them when on location. Your first assistant director (1st AD) will be looking after the schedule and this will have been partly worked out in relation to the storyboard and shot list. If you need to get something else, or you deviate from the schedule by accident, then you need to be flexible to make sure you don't run out of time. If you have your storyboards and your shot list, you will know what shots are essential to make the film work. Having this knowledge will help you make the right decisions in highly pressured situations.

Planning your storyboard

As a planning and communication tool, a storyboard can be useful on a number of counts:

- It lays out the narrative of the whole film in visual form.

- It allows you to see the complexity (or lack thereof) of the film in your head.

- It makes visual the words on the page.

- It shows a producer what you are visualising.

- You can 'try out' ideas for the cost of a sheet of paper.

- You can show the camera/lighting department what you are planning.

- You can visually test out the transition between scenes.

- You can show the production team how many must-have shots you need so that they can plan the schedule. This also allows the production design team to determine how long they will need to secure each location.

- You can see where your shots deviate from the script and whether this is viable.

- You can show actors what kind of movements you are thinking of, allowing them to focus on characterisation.

- You can provide the editor with an initial idea of structure so he/she can begin to assemble footage each day of the shoot – this is particularly important as your film will almost certainly be shot out of sequence.

- You can make sure you have enough reverse angles (for example where you see the back of the head of the person who is speaking with an 'over the shoulder' shot, or even the response to a conversation), often tricky for new filmmakers. You should also think about a variety of other shots to make a conversation look more interesting.

- You can show a 1st AD what coverage they need to ensure is in the can.

- You can 'test' locations.

- You have something to show potential funders.

Glossary

Location scout: The person who identifies the range of options available for a film shoot. They consider creative and logistical issues.

Production sound mixer: The head of the sound department when on location.

Locations are an important facet of the script as settings described are an integral part of the aesthetic form of the film. In a feature film context the search for suitable locations would be conducted by a **location scout** or even a location scouting agency. In some instances, primary location scouting (seeking the most crucial settings) is undertaken by the director and producer with perhaps the director of photography (DoP) and the **production sound mixer**.

For a short film, you still need to scout locations. If you only have two locations, it is probably safe for you to get involved with both. If you have lots of locations, you will need a scout; ask your producer to nominate someone. In the absence of a dedicated location scout this would normally be a production assistant or even the first assistant director (1st AD).

What does a location scout look for?

As a director, you are not responsible for locations, but you are responsible for effectively communicating your ideas and needs to the locations manager and the production designer. In respect of locations, a scout will be considering:

- The concept and aesthetic requirements you have given.
- Ambient sound (is there constant traffic noise in the background?)
- Light conditions.
- Coverage – (can you get wide shots and coverage in the required location?)
- The site in relation to other locations (will it require hours of travelling between locations?)

- Parking facilities.
- Cost.
- The availability of power.
- If it is an exterior location, the proximity of other facilities (toilet, dry locations) etc.
- If it is an exterior location, the likely weather conditions and lighting conditions at that point in the year.
- The ability to gain permission to film in the given location.

Because this is such a time-consuming and complex process, a director can quickly attain a reputation for being difficult if they cause problems by rejecting locations.

Finding the right locations

At an early stage in the production process you will undoubtedly be reluctant to compromise. Reasonable discussion will certainly help you to work out a solution to any problem. However, when it comes to regulations and the law there is little you can do to cajole a location from a producer and a location manager if it simply isn't possible. It's important to be realistic.

To ensure you get the right spot in which to film, your shooting script and storyboards should be as clear as possible. Outline the specific shots you require from your production designer, they should already have the basic visual information but it is also worth explaining why you need the shots you require. This will help them think about alternatives that might work and methods of dressing the set. Discuss the locations with your DoP. They will have to light the space and locate the cameras. You may pick something that looks great but doesn't work as a set. Think of your actors; does the location have enough space to allow the movement they need?

Working in a studio

The temptation for the short film director is to instantly think of building a set. Many big-budget features use a **soundstage** – the likelihood of your getting hold of this facility is limited. Without this, the look of the film will always fall short of your expectations. Remember that audiences are used to films looking professional. There are instances where building a set is your only option. However, there are benefits, for example the ability to remove walls in a small room or shoot and light overhead. If you do this, be careful about mixing 'reality' with your set. It can be better to make sure your overall aesthetic works by making the transition between locations seamless.

Glossary

Soundstage: An interior where sets can be built and a film made. Normally soundproof.

The whole thing about making organic films on location is that it's not all about characters, relationships and themes, it's also about place and the poetry of place. It's about the spirit of what you find, the accidents of what you stumble across.

Mike Leigh, writer and director

Glossary

Casting: The process of assigning actors to roles.

Every script and every production needs good actors. It is therefore easy to get carried away with casting, so remember that it can be a very time-consuming process and plan accordingly.

Screen testing

A screen test is a standard method of casting a film. It simply requires placing your actors in front of a camera and asking them to perform a section of script. The benefits of performing a screen test include:

- Having a record of all the actors before you cast.
- Being able to review and contrast actors.
- Seeing how actors react to a camera.
- Seeing how non-professional actors react to a camera.
- You don't have to be there for the whole casting process – particularly with smaller parts.

You can screen-test actors together, particularly if you have cast one and want to see how they react to another. In a low-budget film, you don't have to use a top-notch camera – any old camera will do.

Casting for a low-budget short film

Generally speaking, your film will require very few actors – after all, short films tend to have very few characters. If you were paying big money then you could expect to get a great character actor or even a star. The difference between a character actor and a star is important in the short-film context. When we see a Hollywood actor, we tend to view them in the context of who they are as much as how they perform. Try and remember the name of a great character actor... it can be difficult because they 'become' the character they portray.

Unless you fall upon great character actors via your **casting** call you are more likely to find someone who looks and sounds right for the part. The trick then is to stop them acting and just be themselves. You can call on local theatre groups or people who happen to look right for the part. Be aware that there are specific considerations for the non-professional actor (these are dealt with on pages 112–113).

Dead Man's Shoes
(dir: Shane Meadows 2004)

Shane Meadows tends to work with recurrent actors, recently
Thomas Turgoose but mainly Paddy Considine. Considine has
also contributed to scripts and concepts. This allowed for the
use of improvisation in *Dead Man's Shoes*. This method of working
closely with actors from the start of a production is a methodology
worth considering.

Locations > **Casting** > Case study: Mike Leigh

CASE STUDY

Mike Leigh

Mike Leigh is an important film-maker for many reasons. One of the most notable and prominent aspects of his work is the development and application of his method of working with actors. Leigh trained at the Royal Academy of Dramatic Art (RADA) and taught at the E15 Acting School in the University of Essex before beginning to direct television plays – two of the most critically acclaimed being *Nuts in May* (1976) and *Abigail's Party* (1977). His sustained interest in, and knowledge of, the potential of actors led to the development of his mode of working.

The method

There is much written about Leigh's method, the best by himself and the actors he has worked with. In summary his method involves:

- Meeting with the actor to discuss people they have met, such as a long-standing friend or a passing acquaintance. One such real-life person is selected as the starting point for character development.
- Leigh and the actor together develop a back story for the character; right down to the finest detail. This involves details of their thoughts and beliefs, not just behaviour.
- Once each individual actor has developed their character, they begin to meet each other – with no knowledge of the other characters or what the film may be about – in the order they would meet in the film.
- The characters begin to interact with the public with Leigh as observer. They are then subject to close scrutiny.
- The actors then exist in character in every interaction and through a series of improvisations where the script is developed based on the structure Leigh has had since the start of the process.
- This method allows Leigh to call on improvisation during the shoot.

You might wish to consider this approach when working with skilled actors you are confident in. It is also a useful tool when working with actors who find it difficult to disguise their true selves.

Pre-production

Selected filmography

- *Abigail's Party* (1977) – Leigh begins his foray into social politics with performances that are consciously mannered to create a real yet overblown sense of 1970s society.
- *Who's Who* (1979) –Character realism gives way to social realism.
- *High Hopes* (1988) – An overtly political film, significant for the balancing of three sets of characters who represent social class.
- *Life is Sweet* (1990) – An improvisational feel, which is often used to comic effect.
- *Naked* (1993) – Notable as being particularly dark for Leigh.
- *Secrets & Lies* (1996) – Leigh continues in a similar vein, but his close examination of race requires a new sensitivity from his actors.
- *Topsy-Turvy* (1999) – Unusual for Leigh in that it is a period piece. There is a sense of believability about the characters, which is supported by the production design but is defined by the performances.
- *Vera Drake* (2004) – Treats its subject matter with a level of realism increasingly absent from feature films.

Conclusion

Mike Leigh is a notable figure but all directors have their own nuances and methods. Investigating figures whose work you respect will allow you to build on their work and develop your own style and method.

All or Nothing
(dir: Mike Leigh 2002)

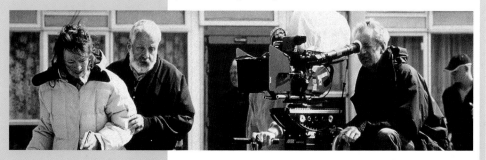

In this production still from *All or Nothing*, Leigh directs the actor for the camera. In theory, all aspects of characterisation will be complete by this stage.

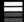

Glossary

Blocking: Planning where the lights will go and how they will hit the actors before shooting gets underway. This is usually done with the lighting crew using stand-ins before the actors arrive to start the scene.

The process of film-making can be highly pressured and fraught. The desire to make things look as good as possible tends to lead to a focus on technology and its creative applications. However, one very low-tech aspect of the process that is of vital importance is rehearsing your actors. There is a tendency to rely on the skills of an actor to carry off a performance with the director merely **blocking** the scenes. This is dangerous, particularly in a low budget film where actors tend not to be as experienced as the feature films we are all familiar with. This is the point where film shares something with theatre and there is a lot to be learnt from the techniques theatre directors use.

Why rehearse your actors?

Actors require information and as their director you know, or should know, more about the characters than is outlined in the script. This is the starting point; clear discussion about the back story and character motivation.

There may be a temptation to forgo rehearsals to bring a level of spontaneity to the production or to rely on improvisation by dressing it as a technique; this is to miss the point of those techniques. When an actor is familiar with a character, they are able to respond in a more spontaneous way and a more considered manner than an actor who has been told little or nothing of a part. In the absence of information an actor will have to fill in the gaps themselves and this may lead to the character developing in a very different way from how you intended.

Who should you rehearse?

The tendency for a new and enthusiastic director is to rehearse everyone possible for an equal length of time. This is a good idea if all your characters are central. However, if you have peripheral characters, then you should consider whether time spent with them is time well-spent. It is possible to give the sub-characters time on set rather than spending a week in a rehearsal room with them for one line. For example, if you were setting out to make *Star Wars* you'd probably rehearse Luke, Han and Leia but probably not Chewbacca or Stormtrooper number 7 (and certainly not an Ewok).

It can be useful to have your first assistant director and a script supervisor at the rehearsals with you. Your 1st AD will be able to consider how a crowd should respond in a scene in relation to an actor's portrayal. A script supervisor will be able to note any inferences or distinctive qualities of language that an actor may add to a script. You can then focus on the main directing of the actors.

What happens if you can't rehearse?

Your actors may be travelling a long way, in which case spending time in rehearsal would be too expensive. They may also be giving their time for free and need to work at the same time as you want to rehearse. If this is the case for you then don't panic. Go back to the moment of casting – are they 'right' for the part? Consider writing extensive character biographies. Think about the tone of voice the character will have. Outline their back story. Think how they move. It can be very useful to consider references to other films and other actors to give a visual clue.

Most importantly in this period of pre-production, build in time to the shooting schedule to rehearse your actors on set.

Techniques for rehearsal

There are many techniques available to you, but an effective process is the most important thing:

- Bring comprehensive notes about the scenes and the narrative. Describe how they should affect the audience.

- Note the objectives and motives of the characters in each scene.

- Consider the visual impact of each scene.

- Evolve methods for developing trust. Consider the various trust games, bonding exercises and other rehearsal techniques that theatre directors use. It is your decision when to use these, but if you are looking for intimate performances, then trust between actors is important. This can really break down barriers for non-professional actors.

- Focus on scenes that are pivotal to the film.

- Start with a read-through to ensure everyone has heard the progression from beginning to end.

- Let actors work on the character and speech before starting any form of blocking.

- Don't rehearse for too long. A couple of hours at a stretch is plenty, particularly in an emotionally intensive script.

- Join in; a good director will demonstrate as well as discuss.

INTERVIEW

Mark Herman directing *Brassed Off* (1996)

Mark Herman is a writer/director who has worked in both shorts and features. His work has received public and critical acclaim across the world, including BAFTAs, Golden Globes and an Oscar. His short films are *See You at Wembley, Frankie Walsh* (1987) and *Unusual Ground Floor Conversation* (1987). His features include the Venice-set character farce, *Blame It on the Bellboy* (1992); the highly political social-realist *Brassed Off* (1996), which is concerned with the desecration of the coal industry and related villages in Northern England; the adaptation of Jim Cartwright's stage play *Little Voice* (1998); the Newcastle-set *Purely Belter* (2000); an adaptation of *Hope Springs* (2003), which is a romantic comedy; and most recently the powerful adaptation of *The Boy in the Striped Pyjamas* (2008) which focuses on the relationship between two children in the midst of the Third Reich.

Where did you start as a film-maker?

Simply as an audience member watching films by people like Ken Loach – not that I necessarily related to [the films] in any particular way. A film like *Kes* (1969) I just couldn't relate to, but it was just enjoyment of the film that drew me to it.

How influential was the diverse experience you had before and at the National Film and TV School (NFTS), UK?

Back then, in the early 1980s, I was an animator, which meant that I was stuck in a cupboard for a year. Once I escaped I was still treated as an animator, meaning that I was given no credence whatsoever. But then I got into screenwriting and it all became more free and easy. For me, that was a great freedom and a great thing to work in.

Did working across different media and forms help with the structuring of the story and the concept of the story?

Yes, I'd written the script [*See You at Wembley, Frankie Walsh*] for graduation and a friend was going to direct it. But then I had one of those moments when I wanted some control over what went on. It's not about being a control freak; particularly as I had no experience of directing at that time. But when you write the script you see images. You can talk until the cows come home about the images, and they will always be different to those a different director sees… Perhaps it is an element of control-freakery.

All your earlier activities were very solitary, how did you begin to work with a large crew?

At first, as I was known as an animator I couldn't get a crew together, or perhaps I was just unpopular! I got an editor and cameraman and an assistant director but they were the only ones from the film school. The quality control was a little nerve-wracking. Moving on to make movies outside in the real world, if you've got any sense, you work very hard on the casting of the crew to make sure they have a similar visual sense of the film to you.

What drew crew to you?

Crew and actors feel that if your star rises they might work with you again. The people from the NFTS went on to do great things. People also believed in the film [*See You at Wembley, Frankie Walsh*] so even though it was a graduation film they felt it might go on and win awards – and they would be associated with that success. Later, the biggest step working on *Blame It on the Bellboy* was suddenly working with professionals who were known for their reputation, rather than who was available. I worked on an 11-minute short, *Unusual Ground Floor Conversation*, for Channel 4, which was a great stepping stone.

It was the Channel 4 name that really helped [in getting the crew aboard]. I had an Oscar for *Frankie Walsh* but had only worked for five minutes and that didn't always go down too well. The big leap was that everyone was so professional and knew their job well. With *Bellboy* it was Hollywood meetings with big shots.

What were you looking for in your crew?

[In a professional environment] you can't say 'I want my mate to light this.' You realise it's the studio who are risking (and making) a lot of money. Without giving up control, a process of bartering goes on. Being 'green', you don't realise how much weight you carry. That award [a Student Academy Award for *See You at Wembley, Frankie Walsh*] got me the meetings... I thought I deserved the meetings on the basis of the film, not the award.

How important was your producer at that stage?

Having Steve Abbott on board got the meetings, on the strength of *A Fish Called Wanda* (1988). The script was commissioned by the British Screen [Advisory Agency] who liked the plot and the humour but thought it stood more chance being international and suggested setting it in Venice and suggested Steve Abbott [to be the producer]. Because of his track record, no one would avoid a meeting with him. A good working relationship formed very early on. What I loved about working with Steve was that he is the nuts and bolts man, making it happen. That was what made the relationship work.

What did the producer do?

He enabled the meetings; I would have to do the pitch. We were in LA for three weeks. While he was in town, they didn't want to miss out on the 'next *Fish Called Wanda*' and he knew how to play that game. The money people wanted to work with him.

How long was the pre-production for *Blame It on the Bellboy*?

Twelve weeks or so. There is always a bit of 'pre' pre-production going on when you get the go-ahead.

What was the next step?

Crewing up – meeting cameramen [sic], designers, editors. As a writer, I'm still script editing [during pre-production] – there are always notes. On *Blame It on the Bellboy*, as it was new, there was still a lot of planning, shot lists, etc. Reams and reams of notes full of pictures that never happened.

There is a lot of scheduling that goes on, once the first few weeks of that are done you know what you are planning for. The assistant director (AD) and production manager do the scheduling, but you are involved as well. The AD is the key person. But you need to be consulted, particularly in the ordering of the scenes; you don't want to start with something that is very difficult acting-wise. Start with something simple. With *Hope Springs* it was Colin [Firth] walking down the street.

Casting is a major part of the pre-production process. You meet with the casting director and have long chats about who you want and then they go out and find them, that's what makes a very time-consuming process less time consuming. The casting agent will have seen hundreds of people, but you'll then see dozens. For a writer, the casting of different actors can affect the script and trigger a rewrite.

What about locations?

The designer and everyone would go and look for locations while I was casting. It's a narrowing-down process. The location team would take thousands of photographs and then I'd take a trip out to view the shortlist. With *Pyjamas* it was the designer and I and the location guy who looked at the locations.

Do you storyboard?

I never storyboard in the traditional way, but in a shorthand way that only myself and the cameraman could understand. Cameramen always do a sketch that is a bird's eye view, architectural, with arrows pointing all over the place; whereas mine is what you see on screen. I'd show the AD both sets, because how you are going to shoot a scene is all about time and coverage. When you get the schedule, you need to discuss things with the AD. I aim to get more than I need, but you need to be reasonable if the schedule is slipping, you have to look at the next week's schedule. But that's part of the job, knowing how to cover things more simply when you need to.

How vital is coverage?

Lack of coverage is the worst thing possible. You always need to make sure you have enough and this can extend the days needed for the shoot. If you are a reasonable person they (the producer, 1st AD *et al*) will understand, and you can give a little back later. Knowing what you need to get when time is running out is important. Time is always difficult and weather is always a problem. If you haven't got the interiors that you can turn to for weather cover you're in trouble. *On Hope Springs,* it rained every day but three out of the whole shoot.

Do you always stick to schedules?

We shot *Brassed Off* in eight weeks. When *Little Voice* came along they thought I could shoot that in eight weeks too, but it doesn't work like that. One of the arguments at the start of that [project] was not compromising on time.

How do you go about rehearsing the actors?

I always get two weeks, but it always disappears. With *Bellboy* it was always a romp because I didn't know where to begin, as there isn't a lot you can rehearse. On *Little Voice*... the cast was half theatrical and half movie stars, who don't do it. You couldn't get Michael Caine to do it. I just showed him the locations, like Mr Boo's club and talked through the scene. Jane [Horrocks] had been playing the part for two years on stage. On *Purely Belter* I did more rehearsal, especially with the children. On *Pyjamas* I thought it was more important that David [Thewlis] and Vera [Farmiga] and the children went around town in Budapest and acted like a family. That was more useful than going through scenes.

You cast the people who get the story and can portray it. With actors, I tend to work on the studio floor and bring them down a bit or up a bit, but it is their performance.

**Hope Springs
(dir: Mark Herman 2003)**

Hope Springs adds detailed character studies and genuine human interest to the romantic comedy genre. Don't allow the conventions of your film's genre become a hindrance; they should be a supportive framework for you and your audience.

EXERCISES

Pre-production is about planning, but only to an extent. It is something you need to practise on your first shoot to help you find your voice and vision.

1

Take a novel or short story and begin the process of adaptation. Through examining what is specific about literature you will learn a lot about cinema.

2

Write a script. You may never engage in script writing again but understanding the complexities of film writing will be useful in itself. You will also become familiar and appreciative of script formats. Also try adapting a script. If it is a feature then take a 90-minute script and make it a ten-minute short.

3

To fully appreciate the complexity of cinema, try breaking a five-minute film or a short sequence into its constituent shots – those which are, to your mind, the most important. Make a note of the main shots on a sheet of paper. This would equate to your shot list. Take the sequence and shot list you've just created and look at the array of 'other' images that are there and what they add to the structure and meaning of the film.

4

Take a person you have seen at a distance. Create their character and write this down as a biography. Now explain this character to a friend. Any confusion they have will be shared by an actor.

5

Take a script and some actors (or volunteers) and organise a read-through. Pause the actors and suggest manners of reading. This will develop your skill in hearing voices.

6

Act in a local film or play. This experience will aid you in your understanding of what it takes to act.

7

Photography is something that requires few resources. Use a stills camera to experiment with framing a shot. The complexities of the cameras and lighting will be down to the DoP, but the way the image works is down to you and this will develop your knowledge composition.

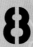

8

Take on crew work on other films. You don't need to be technically minded at all, you could act as location scout, first assistant director or script supervisor. This will aid your process and may aid you in finding a crew for your own film.

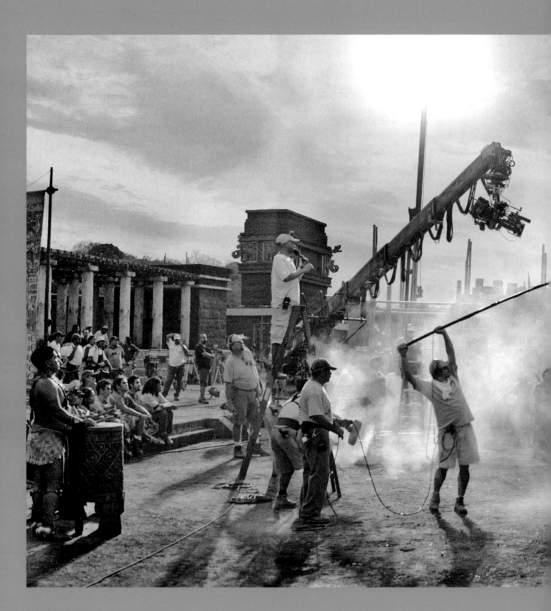

PRODUCTION

Apocalypto
(dir: Mel Gibson 2006)

One day you may have hundreds of people looking to you for direction. Make sure you know what you want and how to communicate it clearly.

Now for the sexy bit; the part where you feel like a real director. Getting out on location and filming things, surrounded by crew, technology and shouting at actors. This is the shortest part of the film-making process, but it can be the most intense and nerve-wracking.

The success of the production is down to the preparation undertaken in the pre-production process. It is worth checking and double checking that everything is in place before you start filming. However, it is also important to be responsive to context and circumstance. Panicking can be disastrous and is best avoided through a clear and composite understanding of what your film is about. You are also relying on the skills and expertise of others. Trusting them with your 'baby' can be the hardest thing of all.

This is the stage of the film-making process when there will be more people around than in any other part of the production. However, if your pre-production has worked effectively, you should now be dealing with very few of them – in fact you may only be dealing with the department heads and then only when you really need to. Your first assistant director is now essential and your relationship with them will be developed throughout the course of the production.

At this stage, an inexperienced director may try to be in close control of everything. Remember that the only way the film will work is if you now trust to your crew and focus on what *you* need to do. The workflow for the production is detailed throughout this chapter. Following the pre-production stage you should have completed the tasks essential to a productive shoot.

Pre-production – what should have been completed

- The script should be finalised – you may want or have to make minor changes during filming but this should be the exception.

- Finance should have been found – running out of cash at this point is a disaster.

- Meetings with heads of department should be complete and agreement about direction reached.

- A shot list should be finalised. The director of photography (DoP) should know what you are looking for and the production department should have scheduled it.

- Storyboards should be finished. If you have used another form of communication, you should ensure that this is comprehensive and complete.

- Casting should be complete, even for minor parts.

- Production designs should be finished.

- Locations should have been found and visited.

- Risk assessments should be complete.

- Permissions should have been acquired.

 If any of the above are incomplete then return to the beginning of Chapter 2 and start again.

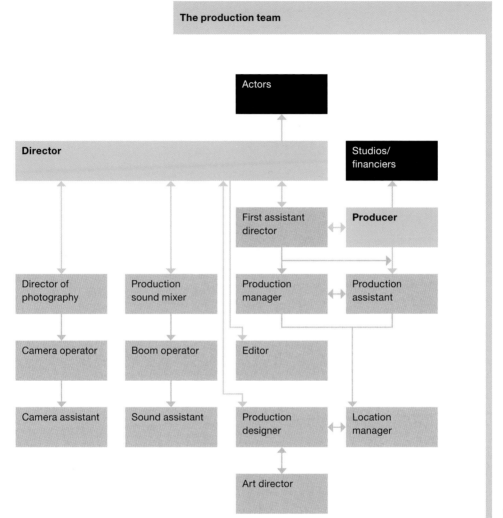

The production team

Actors

Director

Studios/financiers

First assistant director

Producer

Director of photography

Production sound mixer

Production manager

Production assistant

Camera operator

Boom operator

Editor

Camera assistant

Sound assistant

Production designer

Location manager

Art director

The production stage will often be the shortest period of the whole film-making process, but it is also the time when you will be working with the most people. It is now that it becomes most important to have a clear idea of your roles and responsibilities, and where you have to rely on your heads of department. Clear channels of communication are crucial.

The production team > Case study: Robert Rodriguez

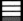
CASE STUDY

Robert Rodriguez

Robert Rodriguez's reputation stems from his early work where he often acted as director, producer, editor, composer, director of photography, production designer, sound editor and so on. It is this multi-tasking that makes him notable and interesting in his production process and film form. However, it also makes him one of the most dangerous film-makers to follow as a model for your own career. He works very much in his own style and it is this that makes him interesting and valuable – but not someone who you should copy.

The Ten Minute Film School

The Robert Rodriguez Ten Minute Film School provides a great starting point and many inspirational messages for new directors, such as:

- Be multi-skilled.
- Be creative from the outset – don't rely purely on money to solve your problems.
- Don't get hung up on technology.
- Write and direct films using what you have around you.
- Write and direct films you understand.
- Work with your mistakes – nothing is ever lost.
- Be pragmatic.

Selected filmography

- *El Mariachi* (1993) – The first film and the one which made his name and defined his style and approach.
- *Desperado* (1995) – A glossier remake of *El Mariarchi*, which some people felt rather undercuts his philosophy.
- *From Dusk Till Dawn* (1996) – A good example of playfulness with genre, with a large effects budget.
- *The Faculty* (1998) – A mainstream, but interesting take on *The Invasion of the Body Snatchers*.
- *Spy Kids* (2001) – The *El Mariarchi* director makes a family film!
- *Once Upon a Time in Mexico* (2003) – Interesting viewing as he returns to *Mariarchi* territory, perhaps evidence of 'auterism'.
- *Sin City* (2005) – Stunningly vacuous yet amazingly popular collaboration with Frank Miller and Quentin Tarantino.

Production

Conclusion

Remember that in addition to talent and tenacity, Robert Rodriguez also had a lot of luck. Making work is important but always remember that you need to know the rules before you break them. An informed, skilled and (most importantly) experienced director will be able to move between styles. So, as you progress in your goal to become a director first learn the established processes and then experiment yourself. Only by doing this will you find your own unique style and approach to film-making. Get the experience, learn the foundations and then experiment to find your own vision.

**El Mariachi
(dir: Robert Rodriguez 1993)**

Note the well-used (and borrowed) 16mm camera, the absent crew and the director/director of photography/everything else.

When speaking with new directors about their influences the same big names appear again and again. There's nothing wrong with admiring the 'greats' but the trick is to be inspired by these people, not to copy them. For example, Woody Allen, Pedro Almodóvar and Ken Loach are all inspirational directors but they also have *very* distinct visual styles and as such are difficult to emulate. On the other hand, directors such as Alexander Payne or Kevin Smith have subtler and in many ways 'cooler' styles which makes pastiche a very real danger if you try to copy them.

The artistry of film-making comes from another place – from the ability to innovate. It is about having enough knowledge to know when something is working well. What is popular is not always what receives the most critical acclaim. Films that receive critical acclaim may vary month by month, year by year. It is therefore the ability to create artistically valid work in different contexts that is the most important facet of the new director's work and it is this that will make you stand out.

Art or innovation?

The term 'art' can cause problems when setting out to make a film. As has been discussed in Chapter 1, the balance of art and business can be complicated, and the same is true when negotiating the relationship between art and innovation. There are some directors who make reference to fine art in their films and it is through these references and allusions that their own work becomes seen as artistic, e.g. Peter Greenaway, Luis Buñuel and Derek Jarman. There are also directors whose original work has been seen by others as artistic or has been defined as such after the event, such as Alfred Hitchcock, Pedro Almodóvar or David Lynch.

Much of the detail of your film will have been organised in pre-production and this is where the 'artistry' starts. If you haven't built in the artistic qualities of your film in pre-production, the danger is that you may try and develop it during production and lose the sense of order a film shoot requires. Process in some ways dictates product, so your process needs to be assured. If you are knowledgeable about your form and knowledgeable about your own process, you are on the way to innovation. As long as your intent is sound, this means that you can work comfortably within established forms and genres and still take them in a new direction.

Production

Innovation?

While the term 'art' is always going to be usefully problematic, the best thing you can do is to consider and utilise the concept of innovation. To innovate is to develop. As Woody Allen famously commented, 'If you aren't failing every now and again it's a sign you're not doing anything innovative.'

This humorous aphorism is pertinent to your development. In trying to stamp your mark, in trying to build on other forms of cinema, you are taking risks. This is where you will find your voice. However, you should never take risks with your crew or your planning. The risks you should take are with your ideas.

The film-maker

One thing is for sure, once you embark on making your first film, you are a film-maker. A lot goes with this – you are no longer an amateur or a student. With this title comes great responsibility. This is not only the responsibility of making a great film but also the responsibility of adopting a professional attitude and employing a professional process. You are representing a long and proud tradition of practitioners – represent them well.

I think that films or indeed any artwork should be made in a way that they are infinitely viewable; so that you could go back to it time and time again, not necessarily immediately but over a space of time, and see new things in it, or new ways of looking at it.

Peter Greenaway, director

Case study: Robert Rodriguez > **The director as artist** > Working with sound and image

**The Cook, The Thief, His Wife and Her Lover
(dir: Peter Greenaway 1989)**

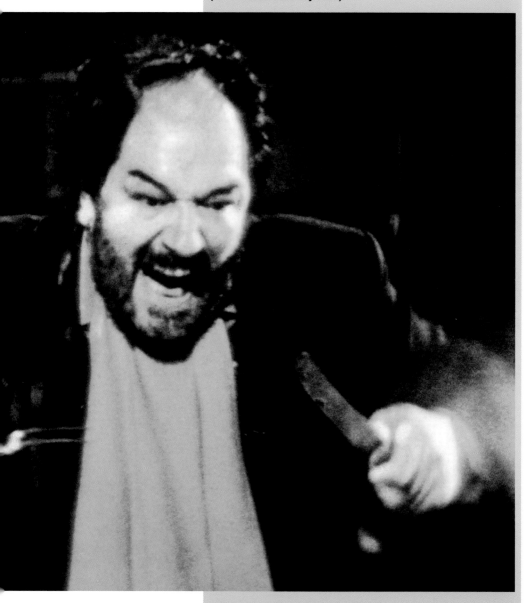

Peter Greenaway's work is visually beautiful in the way of fine art, yet he marries this with complex and interesting narrative structures. Greenaway is unique; in *The Cook, The Thief, His Wife and Her Lover* the aesthetic is stunning, but it is matched by the strength of the performances.

Case study: Robert Rodriguez > **The director as artist** > Working with sound and image

Wild tracks: Audio elements that are recorded separately from the picture, i.e. when the camera isn't rolling.

Boom: A movable arm over a television or film set, carrying a microphone or camera.

The production sound mixer is a vital part of the production process. Sound is often an afterthought and, as such, remains one of the main problems in the majority of short films. Too often we talk of film as a visual medium when it is a balance between image and a range of different forms of sound.

Production sound mixer

Of all the sound crew, the production sound mixer is the one who holds the most responsibility for getting the sound right on a location. Even if you are going to add sound later in the process, it is imperative that what you get on location is clean and balanced. The sound mixer records dialogue, atmospheric sound, **wild tracks** and may also record sound which will be used in post-production.

During location recording, a director should have a pair of headphones on – you need to hear what the production sound mixer is hearing to ensure it matches what you want. You should be able to imagine the music surrounding the scene or the wild track playing alongside the dialogue, but you'll need the sound to complete the image. In order to achieve this you'll need to trust your production sound mixer to locate the microphones in the right place and to balance the right voices.

A production sound mixer will need to consult with the director of photography and production designer to make sure that their equipment isn't seen on screen. As a director, you are looking for clean sound and can leave them to their work. It is up to you to specify exactly what you want from a shoot. Be safe – record as much as possible so you don't find yourself stuck in post-production.

The team required for a shoot is decided by the production sound mixer and producer. On a feature shoot, this would include at least a sound assistant and a **boom** operator. On a low-budget short, you would normally expect the production sound mixer to have no assistant although it is useful to also have a boom operator so the sound mixer can focus on the correct audio mix away from the actors.

Director of photography (DoP)

The DoP is one of the key members of your production team. As noted in Chapter 2, you will have spent a great deal of time working with them in planning your shots and establishing the overall aesthetic of the film. You will also have liaised across departments to make sure that the aesthetic of the film is unified.

The term director of photography (DoP) is still a relatively recent one. The title 'cinematographer' is the traditional name for this key person and in many instances is still used. Some still see the cinematographer as an individual who looks after film lighting and camera work – which is filmed on celluloid. However, with the widespread application and use of digital camera formats, the old distinctions between digital and celluloid have all but collapsed. The difference now is in the nature of the process and the people the cinematographer will have on their team. For example, a cinematographer will need a clapper loader/2nd assistant camera on the shoot whereas you may only need a script supervisor and production assistant on a very low-budget digital shoot.

Getting the relationship right at the start of the production is essential, as different DoPs have different expectations and will have worked in various different ways with other directors. As a director, remember that you are expecting certain things from the camera and lighting department and that in many ways it is up to the DoP as department head to negotiate with the producer in assigning responsibilities within his/her department.

The DoP will normally work with a camera assistant, a script supervisor and a **grip**, even on a low budget shoot. The script supervisor will check continuity; remember that it is very unusual for any film to be shot in sequence. The grip maintains, sets and checks all ancillary equipment, such as tracks, dollies and tripods. On a feature film there would be a number of assistants under each of these individuals. The nature of the department depends on the scale of the shoot and may include people with specific knowledge of and experience with aerial photography, underwater photography, Steadicam operation and crane operation.

Glossary

Grip: A member of a camera crew responsible for moving and setting up equipment.

> One forgets too easily the difference between a man and his image, and that there is none between the sound of his voice on the screen and in real life.
>
> Bertolt Brecht, poet, playwright and theatre director

The director as artist > Working with sound and image > Setting the shot

Glossary

Soft 3D: Working with fabrics and other materials that require little physical building. This is distinct from those specialists who work with costume.

Draughtsmen: People who make detailed technical drawings or plans.

Production designer

The production designer is head of the art department. After the many lengthy discussions about aesthetics conducted in pre-production, they then engage in the production process. Of all the departments, they tend to look after the most individuals. In many short, low-budget films there tends to be very little attention paid to production design and this can be a costly mistake as it is as crucial as any other aspect of the film.

A production designer is responsible for the whole physical aesthetic and mood of your film. Their input is vital in bringing to life the outline you present and furnishing a film with the requisite detail. This may mean anything from manipulating a location to creating something from scratch – and everything in-between.

As with the other key roles, the strength of your working relationship is based around mutual trust. A film is your vision as director, but you can't be responsible for the whole environment and every detail that is contained within it. You should provide an outline and then liaise with the production designer to develop the concept. During production they will be there to respond to requirements if and when necessary.

The production designer normally works with a team of specialists including the art director, who is in charge of logistics; and the set decorator, who look after the physical environment. There are a number of assistants who look after specifics, such as **soft 3D**, graphics artists and **draughtsmen**. On a low-budget shoot, a production designer may also double as art director and assistant.

The movie [*The Brothers Grimm*] is really a fairy tale about the guys who wrote fairy tales. It's also an excuse for Terry to create an entire world, which is what he does so well. He has his wide-angle lenses and extravagant production design. His frames are so densely packed with information. He directs like no one else.

Matt Damon, actor

Production

**The Brothers Grimm
(dir: Terry Gilliam 2005)**

There is a sumptuous quality to Terry Gilliam's work. It is no wonder that he chose to make *The Brothers Grimm* as so much of his work has a fairy-tale quality.

At this point in the process, the production design will be set and the microphones will be in the right place. The most important thing you need to do now is to work with your actors and the director of photography (DoP). You can tell the DoP what you want in descriptive and even emotive terms, but for specifics it is important to understand their vocabulary and some of the key terms they use.

The preparatory work you have done on mid-, wide-, full-length and close-up shots needs to supplemented. After all, you now have real locations with real people moving around on them. Your film has to have emotion attached to the movement of camera (or lack thereof) and it also has to be consistent.

Now is the time to revisit your storyboards with the DoP and to continue this process during the shoot. This is where you balance clear and precise preparation with pragmatism. This is where knowing the overall effect you want is crucial. You will be creating elements that need to link together smoothly; and you will often be creating them out of sequence.

Key shots

Establishing shot: An often-neglected shot that sets the scene and lets the audience know where action is going to take place. This isn't just for the beginning of a film but can also be used at the start of each sequence where the location changes. *The Apartment* (dir: Billy Wilder, 1960) has a moving establishing shot which introduces both location and character.

Long-shot (LS): Intended to emphasise the character in relation to their environment. This shot makes it difficult to get across a character's emotions, which can be useful; for instance in action or in comedy.

Mid-shot (MS): Often referred to as the medium shot. Roughly speaking, this is where the actor's head and torso are shown. This allows for more intimacy and gesture without the detailed emotion of a close-up.

Close-up (CU): As the name suggests, this means getting very close to the action or the actor. The degree of close-up is dependent on the nature of the effect you want to get.

Angle: This can be used to make a character appear either more or less important. For example, in *Triumph of the Will* (Leni Riefenstahl's documentary of the Nuremberg rally, 1935) the camera looks up at Hitler as if at a deity, from the position of the crowd, and down from his position to his audience. The film was, of course, dangerous for many reasons and Riefenstahl's use of these powerful and manipulative techniques make it difficult to accept her defence of it as nothing more than a factual document.

Two-shot: As you might expect, this is a shot of two people together. This is useful for more than just conversations, it can be used to show real intimacy, particularly if the ideas of mid-shot are applied here.

Selective focus/pull focus: This is a switch between a clearly focused foreground and blurred background (or vice versa) to create a dramatic effect of focalisation. There are specialists who are employed for this in feature films. It is hard to pull off and looks terrible when done badly.

Wide-angle shot: A wide-angle shot is often used to exaggerate perspective whereas a wide-shot is as it sounds; normally a static shot capturing the extremities of the *mise en scène*.

Zoom: A zoom is where the camera remains static but the image moves in or out: in to a CU from an LS or MS or vice versa. The resultant effect is to either focus our attentions or to take us away from an emotive moment. The 'crash zoom' or 'commando zoom' is another shot overused in many new directors' work. This technique requires fast zooming in and/or out and is never subtle.

Tracking: Sometimes known as dollying. This is where the camera uses grip equipment to move the camera – often used to follow a character from the front, back or side. The pace of movement has an effect on the audience but is normally commensurate with the mood of the character. A good example of this is the protracted tracking shot at the end of *Manhattan* (dir: Woody Allen, 1979) where Isaac runs to see Tracy before she leaves for Europe.

Tilt: This is where the camera can move in a particular direction to reveal or move from one character to another. This can be up and down or a static shot where an unusual angle is appropriate for effect or genre. Where the camera moves from left to right (or vice versa) on a tripod, this is called crabbing.

Filming tips

- Don't zoom in and out, instead use zoom to compose a nicely framed shot and then leave it. If you use it, only zoom in OR zoom out in a shot.

- Always steady the camera, try using a tripod or resting yourself against a wall. This gives the advantage of being able to frame your shots instead of giving a shaky handheld look.

- Tripods will let you follow the action by panning and tilting (horizontal and vertical movements). This keeps your movie exciting with movement while helping boost the quality.

- If your camera allows it, try to use the manual focus instead of the auto function. This will result in always having your main subject looking sharp. Zoom in close on the subject and focus the ring, then zoom back out to the planned shot.

- If shooting outside or next to a window, be aware that if the sun is behind the subject/actor, then they will appear very dark. Use a reflector or kitchen foil to bounce light back onto their face.

- Try to stay away from the camera's own special effects, titles and date functions. There are far better effects available when you get back to editing it on the computer.

- Sound is very important. You should have headphones on location so you can block out live noise (sound) and only hear what the camera is picking up. And the camera will pick up a lot of noise. You need to be aware of planes, traffic, people and so on.

- Try not to centre your subject/actor in the middle of the screen. Moving them slightly to one side of centre works much better.

- When going for a take, make sure everyone is ready and let the camera run before you shout action. You don't want to miss the beginning of every take.

- Make each take a minimum of ten seconds so you have enough to work with in the edit.

- You should get the actors to go from just before the shot wanted to just after on each take. This will help you cut it together in the edit. Without this, the film looks jerky and unrealistic.

- Unless using professional actors, you might want to brief 'the talent' not to look into the camera while going for a take – they have a habit of doing this.

Techniques to be used advisedly

Point-of-view shot (POV):
With POV, the camera takes
the position of the character
and the audience sees what
they see. The image on the
screen is essentially the 'eyes'
of the protagonist. This is a
very blunt device and as such
it is used sparingly in cinema.

Hand-held camera (HH):
This technique was a
mainstay of the Nouvelle
Vague in the 1950s and 60s
and was used to great effect
in *The Blair Witch Project* (dir:
Daniel Myrick and Eduardo
Sánchez 1999) to create a
'documentary' or 'rushed'
style. However, be very careful
about the effect of mixing HH
with other forms of camera
work as this can look clumsy
and forced.

**Casablanca
(dir: Michael Curtiz 1942)**

This famous scene from *Casablanca* shows the power of the
two-shot. There is no need for the camera to move at all. The
framing of the shot does the work; the emotion it creates fits the
mood and the genre.

CASE STUDY

Martin Scorsese

Martin Scorsese is one of the most important film-makers working in American cinema today. Much has been written and even more has been said about Scorsese, mostly about the thematic relationships between his films; redemption, violence, masculinity and the nature of immigrant identity in New York. Less has been written in relation to Scorsese and composition. However, the importance of form is evident across a range of his films. Scorsese exemplifies the director who is an expert in his own medium and his influences come through in the diversity of the work he produces.

Variation in form

Scorsese has directed 33 films with a wide variety of styles. Broadly speaking, they can be divided into five categories: documentary, documentary influenced, overt fiction, character-driven intimacy and epic.

It is worth surveying a range of Scorsese's films to fully appreciate how and why this variation of form occurs. Scorsese has returned to documentary throughout his career. (In fact he worked as an editor on the 1970 document of the Woodstock festival.) This documentary style also featured heavily in films such as *Mean Streets* (1973). This gave way in the 1980s and beyond to a glossier visual style, finding a peak in *Casino* (1995) and then a move to epic film-making with *Gangs of New York* (2002). All of these films contain detailed character analysis, but the intimacy and intrusion of the camera is specific to films such as *The Age of Innocence* (1993).

The filmic relationships of Martin Scorsese

Documentaries

- *The Last Waltz* (1978)
- *No Direction Home: Bob Dylan* (2005)
- *The Rolling Stones: Shine a Light* (2008)

Production

Documentary influenced: Films that use a hand-held style (at points) and a feel of immediacy and presence for the audience. It feels as if you are there. Note the kidnapping in *The King of Comedy* for instance.

- *Mean Streets* (1973)
- *Taxi Driver* (1976)
- *The King of Comedy* (1982)

Overt fiction: Overall this style of shot is to make no pretence than the film is anything other than fiction, although the performances counter this. *New York, New York* is the prime example of this as the sets were specifically designed to look artificial, also note the car boot sequence in *Goodfellas*.

- *New York, New York* (1977)
- *Goodfellas* (1990)
- *Cape Fear* (1991)

Character-driven intimacy: The action tends to dwell more on the actors and their emotional response to events and dialogue. The camerawork is not evident. Note the discussions between Costigan, Dignam and Queenan in *The Departed*. This style is partly influenced by Scorsese's hero, Michael Powell.

- *Alice Doesn't Live Here Anymore* (1974)
- *After Hours* (1985)
- *The Departed* (2006)

Epic: Films that inevitably contain moments of intimacy between characters but where scale is at the forefront. These films are characterised by a combination of the intimate with the scale of classic Hollywood.

- *Raging Bull* (1980)
- *Gangs of New York* (2002)
- *The Aviator* (2004)

Conclusion

Scorsese is a classic example of an auteur who can move between genres and styles with ease. Examining directors such as Scorsese demonstrates that you don't have to be a slave to a particular oeuvre just because your first film is successful. Taking risks with form and content can pay off.

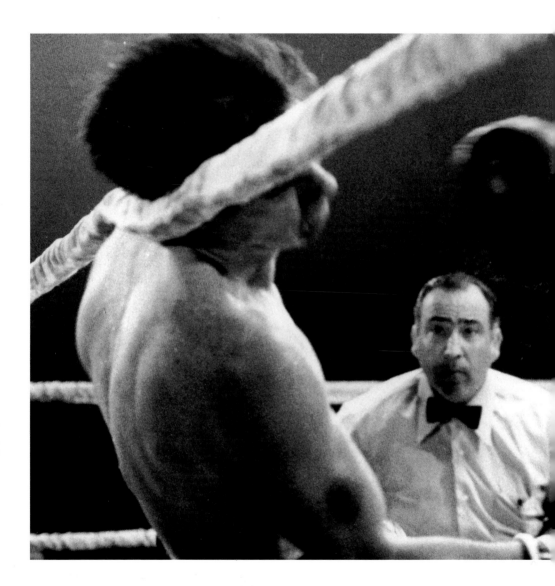

**Raging Bull
(dir: Martin Scorsese 1980)**

Raging Bull is an interesting example in the range of Scorsese's films. In terms of the shot construction it embraces the realism of his early fiction and documentaries in the fight sequences with the epic qualities of some of his later work when the fights start, but with the intimacy of his character-driven dramas. In this scene the brutality of the fight is portrayed to perfection by Robert DeNiro. Whilst this fills the screen, it is juxtaposed with exquisite black-and-white photography. This forces questions about spectacle and violence in the mind of the individual audience member.

Once again, when it comes to technology you must rely on your team. A director is not a technician and even when directors have experience of working in other more technical roles, they must remain focused on the job in hand. However, in terms of the low-budget film production, it is best to know what possibilities and limitations your equipment offer you. This will help you know what your options are and what you can achieve.

Sound

Sound is the aspect of low-budget film that is most often ignored. This isn't helped by a lot of low-budget equipment having little in the way of good quality-sound connections. You should always investigate what your sound department is planning. If necessary it is possible to record your sound on a separate source and synchronise it in post-production.

Sound mixer, boom microphone, radio microphone

Left: The sound mixer allows for a balance between microphones and to ensure consistent sound levels across a production.

Middle: A microphone normally attached to a boom pole and held out of shot near the actors, usually overhead.

Right: The radio microphone is a valuable but costly piece of equipment that allows for long-distance recording of sound and the subtle placing of a microphone.

Images

The image quality is, of course, crucial. Remember that as a director it isn't your responsibility to know the details of how the camera works. You should be prepared to request the size; 16:9 is the cinematic convention. The only other major decision you make is whether to shoot on celluloid or High Definition Digital Video (HDV). For low-budget films, HDV is by far the most cost effective option.

Camera, lights

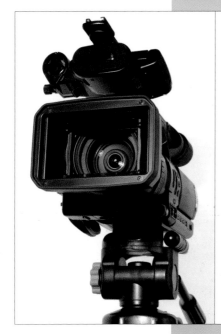

Left: Any camera can be used to get started but as you progress you should be looking for a camera that has more manual operations. This will enable you to ask your DoP for more creative camera work as he/she will have full control over the focus and aperture.

Right: Lighting needs careful consideration and an experienced DoP will be a huge help in organising the aesthetic for you. Basic lights, such as the one illustrated, are valuable when filming inside. Don't base too many of your lighting expectations on Hollywood movies if you don't have the budget for the equipment. You are well-advised to conduct shoots in a location where you can control the light as much as possible. Discuss reflected light with the DoP when working outside.

Jibs and cranes, Steadicam, track

Left: A jib, and its larger cousin the crane, allow for high shots and fluid movement in all directions.

Middle: The Steadicam requires specialised operation and is intended to provide fluid movement without the need for track, allowing for greater flexibility. There are other cost-effective versions available, such as a glide.

Right: Track (and the related term, dolly). Tracking is essential for smooth camera movement. This comes in straight and curved sections.

Glossary

Squibs: Small fireworks often used to create the effects of gunshots.

Prosthetics: Artificial body parts.

Animatronics: The technique of making and operating lifelike robots, typically for use in film or other entertainment.

Most contemporary films tend to use post-production visual effects, but this doesn't mean that you can ignore effects during the production stage of film-making. There is still a need and a use for production-based visual effects, depending on the form and type of film you are making.

Should you use effects?

It is unusual to find a low-budget short film that uses many visual effects either in production or post-production. This is for a simple reason; if they are done badly, they look terrible and could ruin what might otherwise be an exceptional film. First-time directors tend to think of something such as advanced pyrotechnics as an effect but fail to note that staged car chases, gunshots or fight sequences are also effects and difficult to capture. When you are first planning your shots, consider whether there is an alternative method of filming these kinds of scenes or whether they are needed at all. For example, in *Down by Law* (dir: Jim Jarmusch, 1986), which follows three prisoners on the run, the prison break itself doesn't appear at all. This is largely because it is not important to the narrative, although it would undoubtedly have had some spectacle. It's important to be clear about what you need and what you can achieve.

Who looks after visual effects?

This is normally a visual effects supervisor. This highly specialised individual works in tandem with the production and post-production team to ensure consistency in the application of the effects. On a low-budget shoot it is always worth consulting with a professional. The visual effects supervisor is there to enact the creative wishes of the director; in doing this they have to be highly trained and in respect of your film, safety is paramount. The specialised nature of the activity is due to the inherent dangers that are often part of the process. The aesthetic issues and health and safety concerns make all effects worthy of careful consideration.

Key effects

In determining the kind of effects you will be using, it is important to think of them as visual effects rather than just special effects. All films have effects of some kind and some are logistically simpler than others. These can be categorised in the following ways:

- Physical effects: These are normally the kinds of effect that require physical actions on the part of the actor and may involve some specific skill or training in order to complete it. This would include stunt work, fight sequences, fencing, horse riding and car chases.

- Special effects: Effects which require some specific or special technology in order to make them happen. They might include **squibs**, pyrotechnics, **prosthetics**, fog machines, rain machines or **animatronics**.

- Camera effects: Undertaken by the production team or specific subsets of the production team experienced in the effect. These would include lens flares, dolly zooms and so on.

- Visual effects for post-production: These require very careful and specific planning as they need to segue with the post-production processes. These include chroma key (blue screen), motion control, motion capture, etc.

See page 141 in Chapter 4 for specific post-production effects.

There are so many effects and so many things that are done digitally now that it's so hard for the director to really control the process, because there are more and more experts that come in.

John Frankenheimer, director

In 1924, Captain John Noel made the documentary film *The Epic of Everest,* which followed the infamous ascent of Mount Everest during which the climbers George Mallory and Andrew Irvine disappeared into the mist, never to be seen alive again. The making of Noel's film required the manufacture of a special camera, high-altitude climbing and working in sub-zero conditions. So, if as you're making your first film you feel that location work can be difficult, just be grateful that it will never be *that difficult.*

Start with confidence

Confidence on location is built around two things. First, the foundations you have built with the crew via a careful planning process, and secondly your knowledge of the location. This is where careful and complete information from the location scout pays off. Obviously you should have also visited the location in advance along with the key heads of department. Any issues will have been resolved and your production design team will have completed the aesthetic of the environment.

The key is never to lose sight your plans, even in the moments where everything appears to be falling apart or, conversely, not to get complacent when everything seems to be going well.

Dealing with the stress

The last thing the crew and especially the cast want to see is the director exhibiting signs of stress. Being calm and collected is the key to success, even if behind the scenes is a very different story.

Be single-minded when on the shoot. Distractions will come thick and fast with everyone demanding your time. This makes prioritisation vitally important, which requires carefully listening to those around you and evaluating every situation logically. This is the time when your hours of pre-production planning will really come into play, but even the most experienced directors still face unforeseen problems.

Problems often arise from factors outside your control, such as the weather. A good first assistant director will provide alternative shots if the weather isn't suitable for whatever has been scheduled for a particular day, but this isn't always possible. When this happens, the pressure of not shooting can cause grave difficulties. Knowledge of the story will allow you to make quick, informed decisions without compromising the film.

Maintaining focus

During the take, your focus should be on the monitor and listening to the sound. Your concern is how the film will look on the screen. You are putting yourself in the position of a member of the audience and to do this you must have a clear vision of how the images will work when layered with sound and effects. This is difficult in the heat of the moment. Work with the script supervisor to note which takes are working to aid your reviewing of the material in post-production.

If you are unsure whether what you are hearing is an accurate recording of the sound, then quiz the sound department. If you are unhappy with the lighting or camera angles, then quiz the director of photography. Asking questions at this stage can cause minor delays but it is vital to get what you need for each scene now. Filming schedules are important but only when you are sure that you have the footage you need. Without it you have no film.

The importance of the monitor

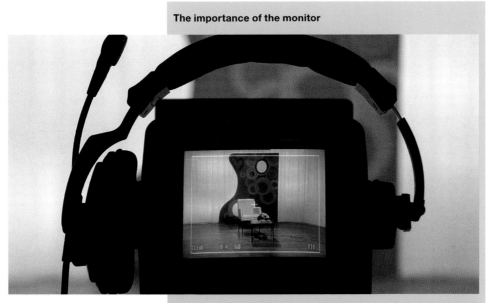

The most important thing you can do is to focus on what the film will look like on screen, not what it looks like on location. The only way to do this is to focus on a monitor. On a low-budget shoot, this may be the camera LCD screen.

Production effects > **Working on location** > The first assistant director

Passion is crucial

There has to be a sense of enjoyment or satisfaction, otherwise making the film is without purpose. Some directors are driven to make a statement and it is in this that the ultimate fulfillment comes. Maintaining passion in the heat of the moment can be tricky and so must be rooted in your own belief and confidence in the quality of your idea. You can also maintain momentum by showing your confidence and belief in the team surrounding you. Place faith in your crew and they will place faith in you.

Despite the pressure, film sets should be exciting places. After all the long, studious hours in pre-production, there should be an element of fun about being on location – otherwise no one would do it. The moment when you shout 'action' should be one of the most exciting of your life. The cameras start rolling and the actors start bringing your ideas to life; it is like magic.

Most of all, it is important not to try to 'wing it'. Any absence of professionalism or control will be quickly spotted by the crew. It isn't their job to keep things going. Most directors battle the pressure with constant preparation and development. There is great solace in knowing that you are armed with all the information you need.

After a day of shooting, it is useful to conclude with a meeting with the editor to review the footage. You will then know what has worked and what hasn't. If you don't have the opportunity for this then review the material as soon as you can. Meeting with the first assistant director is invaluable. They have their finger on the pulse regarding schedules. They will know what can be changed, developed or augmented depending on your requirements. Always listen. You know what you need, they know what is possible.

This adherence to process at the end of a difficult day of shooting can sometimes feel arduous, but once you get stuck in it can often reignite your passion for the project. This is where you can see the fruits of your effort come to life. Imagine what this will look like on the big screen and let the 1st AD take the responsibility for making it happen.

All I try to do is create an atmosphere that seems comfortable enough that it removes tension and everyone feels free. If they feel free then behaviour happens, small moments happen and that's what ultimately works the best for me.

Barry Levinson, producer, director, writer and actor

**The Cardiac Oak, or A Death in the Darkling Wood
(dir: Alasdair Beckett-King 2006)**

In this example, the set is clear, the woodland location means there are no bystanders or traffic to contend with. The director is clearly focused on the monitor and communicating with the actors while the DoP and camera operator do their work. This is where the real satisfaction comes from.

Glossary

Call sheets: A sheet of paper issued to the cast and crew of a film production informing them where and when they should report for a particular day of shooting.

Metafictional: Fiction in which the author self-consciously alludes to the artificiality or literariness of a work by parodying or departing from novelistic conventions and traditional narrative techniques.

The nature of the first assistant director (1st AD) role has changed during the development of film. Historically, the 1st AD was the assistant director and this was a position taken by those who wished to move to directing later. In current cinema practice, the 1st AD is a member of the production team under the leadership of the producer. However this relationship shifts during the production process and they are still of vital importance to you as director.

Organisation should be simple

In pre-production the 1st AD works as the link between the producer and the director and draws up a schedule that meets the needs of both. This includes examining what needs to be booked or hired to make sure the shoot happens in the way that you have envisaged. In the first instance, this is done by working with the script. When the shoot begins, the 1st AD works more closely with the director to ensure that the schedule is adhered to.

In theory, the work of the 1st AD sounds simple but in practice there is an awful lot for them to do. This is particularly true where a film may have a series of extras or crowd sequences and you may wish to give specific direction to your 1st AD to help if you have a lot of these scenes. In short films, crowd control may not be a problem but the role of the 1st AD is still very important – you need their help to keep the film moving forward.

The other ADs

The 1st AD is a crucial role but it is normal on a feature shoot to have a second, a third or even more assistant directors. It is common to have these people on a short-film production, too, but these are often mistakenly referred to as runners. On an extremely low-budget shoot, it may be the case that a 1st AD takes on board all the AD duties, if this is the case it is important to realistically assess their workload.

The 2nd AD tends to do more of the physical organisation of people. This involves placing people in crowd sequences and ensuring the actors are ready for their shoot in terms of make-up and wardrobe. With this in mind, they also often generate **call sheets**. The 2nd AD therefore supports the 1st AD in the complexities of their organisational work. The 3rd AD is often a variant of the 2nd; however, in recent years this has come to mean an individual who deals with the movement of actors and occasionally crew to and from the set and who would have a clearer focus on extras.

**A Cock and Bull Story
(dir: Michael Winterbottom 2005)**

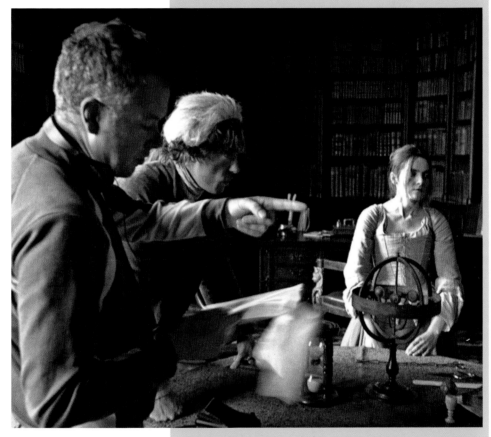

A Cock and Bull Story is a **metafictional** film about the making of
a film from an 'unfilmable' novel. In this scene, the real director, as
opposed to the fictional 'real' director, sets the scene. This film is
highly tongue-in-cheek about the whole film-making process, but
gets closer to the truth than many text books – especially as it shows
the 1st AD retaining control while the director pacifies the actors,
and massages their egos.

The importance of rehearsal will become evident on set, especially if you haven't conducted any. Sometimes, especially in short film, rehearsal will not be possible. This is where you test the strength of your casting.

The actors are what make the film work. Actors portray the characters that make a film live for an audience. The relationship you have with the actors is crucial. Professionals can, on occasion, be needy. Non-actors can be anxious. Either way, actors are prone to nerves. It is important to provide the actors with information and details about what is happening on the day of the shoot and what is required of them and when.

Organising the actors

The 1st AD is valuable here as they are now playing chaperone to the actors (in addition to all their other duties). They are the actors' first point of communication and everything should be filtered through them rather than directly to you. The 1st AD will also have created call sheets. There is nothing worse than an actor being called at the wrong time and then having to wait around on set for a long time.

The second level of organisation is your blocking. Even the most carefully laid-out rehearsal room is not the same as a set and even the most experienced actor may not know where to stand or which way to look. One of the most common errors can be attributed to a lack of blocking. If you don't direct them, an actor may look directly into the camera and in fact this is likely unless they have been told otherwise. Allow the actors some freedom when you start this process and then move in to manoeuvre the environment.

I'm a skilled professional actor. Whether I've got any talent is beside the point.

Michael Caine, actor

Getting ready for filming

Once you are close to calling action, it is valuable to allow the actors to walk through the scene to hit their marks. This also allows the DoP to set the cameras in relation to the actors' timing. The crew may then need to readjust the lights, the microphones and other equipment. This is a good opportunity for you to then concentrate on the actors' performances. Often, this is simply a case of leaving them alone to get into character, but check to see that they don't need additional assistance. If they need space from you and the crew, let them have it (within the parameters of time).

Running the scene with the actors in place is always effective. This tests the position and means that your first take will be more effective. You might want to tell your actors that you are rolling to allow them time to get into character and move into the scene slowly. This allows you more material at the start of the take to fade through during the edit.

Depending on the amount of time you have, you should consider how best to provide direction to the actors. Shouting from the back is quick and allows you to view the monitor throughout the whole process. However, if things are going wrong or your actor is particularly nervous you may want to provide quiet direction.

Filming

Once everything is set, you are ready for the first take. Despite all your preparations, it is worth noting how you can nudge a performance along during the takes. Once the actor has one under their belt, they will relax into the part. Even if it looks like the performance was fine on the first take, get others. This is good for security and you may find the performances get better and better.

Tell the script supervisor to take careful note of the specifics of an actor's performance for any reverse angles or close-ups you need.

Rewarding actors is a good idea – we all like praise. Actors are often performing emotionally difficult material. Making sure that you compliment their performance is helpful in ensuring that they sustain their performance across a number of takes. Once you have finished a scene, it is worthwhile spending a little time with your actor outlining the next scene to be shot – particularly as you are more than likely to be filming out of sequence. This then ensures that there is emotional continuity in the 'real time' of the film.

Remember that whatever the problem is, there is no point getting upset with the actors. Often the problem may be your fault for not explaining your requirements clearly.

Working with children

The old adage about never working with animals or children stems from actors and directors who have had to deal with many hours of tears and tantrums. However, if the script calls for them, then you have to find a way to make it work. Animals are wholly unpredictable and so are children. In the low-budget field, it would be unusual to work with a professional or experienced child actor.

Whatever status your shoot has (professional or amateur) you have legal obligations when working with children. Your producer and production team will sort out the details but it is worth knowing these as it must shape your approach to making the film.

It is vital that there is a parent or guardian on set at all times observing all interaction with the child. Consent must be gained in relation to what the script outlines. You can't add scenes at the last minute. Above all, sensitivity to the moral, emotional and physical welfare of the child must be maintained at all times.

We are older now... so it is good for us to feel like we're not just child actors any more. We've grown up and are now able to make our own acting decisions.

Daniel Radcliffe, actor and star of the Harry Potter franchise

Production

Common problems and how to solve them

Challenge
An actor can't stand still.

Suggested solution
For non-professional actors, this is a common problem on stage as well as screen. This can manifest itself in wild gestures. Try shooting in close-up.

Challenge
An actor can't emote physically.

Suggested solution
This is a difficult issue when you have little time to work to loosen their actions. It may be a case of simply shooting in a different way. Think about how you can reconstruct your shots to get more close-ups or how you could capture lots of reaction shots from other actors. A good vocal performance can be layered on in post-production, as long as you have the images to give the scene meaning – this doesn't always have to be of the actor who is speaking.

Challenge
Two actors don't work well together.

Suggested solution
Occasionally two actors don't work well together, often referred to as 'lack of chemistry'. This is not the same as falling out, which is a different problem and there is little you can do other than keep them apart.

Challenge
An actor can't deliver a line in the right way.

Suggested solution
Try to get them to experiment with the line. Allow them to suggest alternative phrasings that work for them (as long as it doesn't adversely change the meaning). Suggest the stress point in a sentence be changed, although that can change the meaning, too. Only as a last resort should you ask an actor to mimic you.

Challenge
There is no emotion in an actor's delivery.

Suggested solution
Check on the physical state of your actor. Remember that as long as you have one emotive performance then you can use this in the edit, but you'll need to shoot accordingly. The answer can often be to get the actor to do something physical. Even if this is lifting a heavy weight while delivering the line. As above, you shouldn't ask an actor to mimic you.

The importance of rehearsal will become even more evident on set with non-professional actors. Where you haven't had the opportunity for any rehearsal you will have to employ very specific skills in teasing out the performance you require. Casting is equally important with this group, but bear in mind that even if you have cast someone with the right look you are not guaranteed to have a skilled performer.

While working with non-actors can bring a series of problems, it can also bring with it a series of benefits. The performances you get can be more natural and enthusiastic, and they can be more receptive to your advice. There is a long history of directors choosing to work with non-actors; from Vittorio De Sica's *Bicycle Thieves* (1948) to Steven Soderbergh's *The Girlfriend Experience* (2009).

The non-actor's background

It is always worth reminding yourself of the actor's background. You can assume a certain level of training and experience from a professional but there will be many variants of non-professional actor. There tend to be three broad groups:

- The semi-pro: Quite often a member of an amateur dramatics organisation. These organisations are a wealth of talent and contacts. The actors who fall into this camp may see themselves as the equivalent of professionals – their experience is almost always theatrical rather than filmic. There are also many individuals who enjoy acting purely in films. These actors are best sourced via film networks.
- The enthusiastic amateur: In some ways this is the most difficult person to direct. This type of actor often has a very set idea of how a performance should be and requires specific and special treatment to create a subtle performance.
- The reluctant performer: Often the best performer in a film as the natural qualities they have are the ones that you want to ensure come to the fore.

Getting ready for filming

Depending on their relative levels of experience, most non-professionlal actors tend to be very nervous. With this in mind, it is best to discuss with your 1st AD devising a call sheet, so the actor isn't spending too much time on set with little to do (becoming increasingly anxious). As with professional actors, it's also important to remember that a film set is a highly unusual environment and it is very important to ensure that the context of each scene is explained clearly.

Start with the most emotionally draining aspects of any scene. It is often thought that starting with a simple sequence or with reverse angles is best. However, this kind of gentle introduction can just give the non-actors time to feel increasingly anxious.

Getting a precise performance can be difficult – getting a performance that can be repeated is harder. It remains good practice to walk through the scene with the non-actor, but be clear about what you want them to do. The actor will not necessarily be instantly able to fill in a back story or provide a great deal of character detail – that is your job. It can be helpful to act the scene out yourself.
This exemplifies your direction and also breaks down the often difficult feeling of embarrassment of performing in front of a crew of relative strangers.

Reassurance is always useful. The practice of barking through a megaphone from the back of a set is not necessarily the best. Advice and critical commentary should be supportive, developmental and given quietly. Praise should always be public.

Filming with non-professional actors

- When filming, remember that the process is similar for professional and non-professional actors.

- Make sure you give yourself time for plenty of takes as the chances of fluffing a line are much higher.

- Recognise that there may not be consistency in the performances and as such you may need to direct more closely than with professional actors.

- Note the best take in respect of how the piece will be edited – this allows you to take aspects of different takes as you go along. This helps with selecting how to conduct reverse angles.

- Remind your actors of the sequence.

- Allow the non-actors the ability to play with the words as best suits their voice, but only where this can be remembered and reiterated.

- Watch out for overacting. This is often a danger with movement as well as voice. Bring down the performance whenever this happens.

- Be careful in working with actors more familiar with theatre. Remind them of the closeness of the camera and thus of the audience. This will help them tone down their performance.

Working with actors > **Non-professional actors** > Reviewing your material

As you've been working on your film, ideally you will have been sending the material back to the editor to capture and assemble. Even the most experienced film-makers with teams of people surrounding them can find that they have missed a vital shot or they haven't got enough images for a sequence to make sense. Reshoots or additional shoots are complex and expensive.

Assembling the film

Normally, editors are viewed purely as part of the post-production team. However, post-production can often start before the end of the principal photography, at least in terms of assembling the footage for review. On major film shoots it is common to have an editor on location to begin the process of assembling the film.

While post-production occurs after the film is finished, the process of assembling the film during shooting is for the director to get a sense of how the film is developing and what shots have worked. This process is reliant on up-to-date shot lists and the help of the 1st AD is crucial.

The editor may have some provisional selection of shots at this stage but would normally make all the shots available to the director. This is partly to ensure that the progression of the scenes is working, but is largely to avoid reshoots before filming has wrapped.

This mode of assembling and reviewing is not to be confused with the initial rough-cut of the film undertaken in post-production, although it may feed into it.

Coverage

One of the major issues for many films is not having enough material for the film to work in the edit. First-time directors tend to focus on the main scenes and the main sections of the scenes. This means that there are two categories of shots that are often low on the list of priorities and so are easily forgotten in the heat of the moment:

1. Establishing shots

At the beginning of a new scene, an establishing shot introduces the audience to the setting, time of day and characters present. These shots are not generally detailed by the writer in the script and are therefore normally identified and scheduled in the planning stages. Establishing shots can act as a refrain or a punctuation point to your film. Just as punctuation in the written word allows for a pause for effect, establishing shots allow you to prepare your audience for what is to come.

2. Reverse angles

Reverse angles are vital when filming dialogue as they will help you to avoid the temptation to film a mid-shot of people talking and holding on to it for the whole scene. If the selection of dialogue is long, the danger is that a single mid-shot will be pretty dull for an audience. Equally, if you imagine a dialogue sequence made up entirely of faces shot from the front, it would look very odd indeed. Instead, a full-face shot is best used as a point of dramatic emphasis. This doesn't have to be the person speaking – often the interest is in the person who is listening. Look at any film with a dialogue sequence and see how the director has worked with the shots to make it seamless and interesting.

Capturing emotion

Just as in a police mugshot, the interest is in the full-face shot – this is the image where we can see the criminal/actor's eyes and where the emotion is shown.

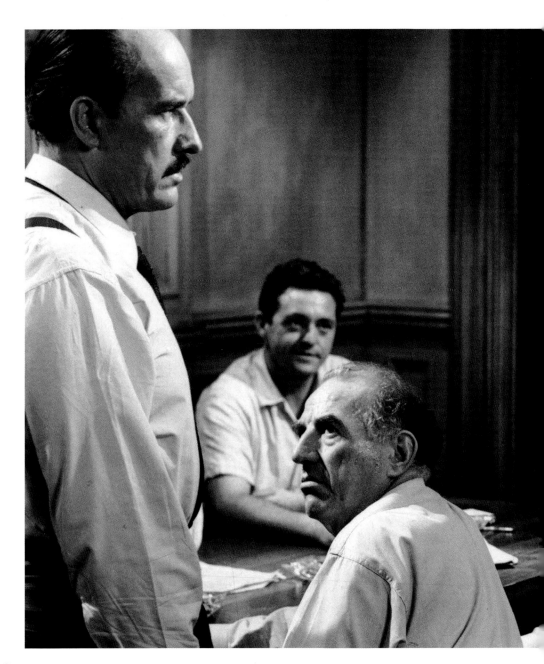

12 Angry Men
(dir: Sidney Lumet 1957)

12 Angry Men is entirely dialogue based and is a masterclass
in how to construct a film in a single location.

INTERVIEW

How do you work with actors on set?

I give the actors complete freedom to run the scene and the director of photography and I watch. Then I get the stand-ins in and we set the scene and decide how to get the coverage. The actors would hate to be told to stand there, do this, do that.... In *Little Voice,* we sometimes brought the actors in and we hadn't set up [the scene, lighting, camera positions and sound] and that wasn't the best, but they know that everyone has a job to do.

What about the camera set-ups?

Ninety per cent of my shots are in track, grips are so important. Laying the track is part of the routine. It [the movement] makes it feel like a movie and the audience don't always see the camera when it creeps slowly. *Bellboy* was much more out-and-out farce whereas *Brassed Off* was much more about character work. The camera was therefore more often static on *Bellboy* as we didn't need the detail of the characters' faces.

And sound?

With sound it is usually technical on set. Things sound so different on the studio floor than they do through the cans. Over the films I've noticed how different sound recordists can add a different flavour to the recorded sound.

How do you work with your first assistant director?

On location, the 1st AD shouts and is a voice of authority, which makes up for my small voice, but you do need the loyalty and the authority. You need someone who can tell when you are getting annoyed or disappointed before everyone else does. It's a very important relationship, not just about scheduling.

Is your producer still involved while you are shooting?

The producer is still important, but they are not worried about what is happening on set on a day-to-day basis.

Do you assemble the film as you go along?

I have always had an editor on location, not on set. In my case, Mike Ellis doesn't want to know the set-up of the scene because it might influence the way he cuts it. He has a little studio and is cutting from day one. On the day off, I'll go into the cutting rooms.

How do you maintain focus?

Pyjamas was ten weeks, two weeks overseas. You are at work, and its full time. In all the time in Budapest, I was either shooting or in the edit rooms. That's what you are there for, that's the job.

The Boy in the Striped Pyjamas (2008)

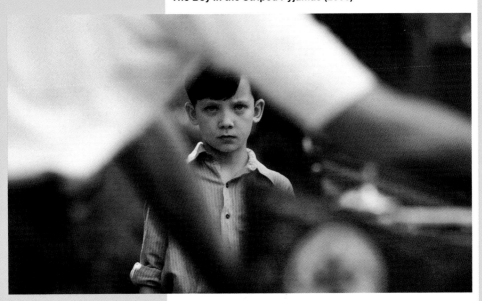

Usually, an audience should not notice the editing, or any of the artifice of film production; this is particularly true with a story as sensitive as *The Boy in the Striped Pyjamas*.

EXERCISES

You should now be ready for production. Your producer should have provided you with contingency time so don't worry – get out there and make your film.

1
Make a two-minute short using very basic of equipment. See what is possible with limited resources to stop yourself becoming too reliant on technology to make the film.

2
Play around with the equipment you are going to use to make the film. You won't have the time to become an expert but it can be useful to know the limitations and possibilities of your tools.

3
Make a five-minute silent movie. Honing your visual skills before you start working with sound will be helpful later on. Next, add Foley sound to your silent movie. Finally, add different scores to your silent movie.

4
Take a script, even a stage play, and make it as a radio drama. Your understanding of the power of voice and sound effects will be heightened when they are all you have.

5

Take a scene from a well-known film. Re-shoot it but change the type of shots used. Assess how this fundamentally changes the meaning of the film.

6

Try directing a short stage play. This forces you to focus on actors, without the added complexities of cinema. Once you have directed the play, work on filming it. This will focus your attentions purely on actors rather than locations. The test is to make it interesting and filmic.

7

Work on costing a film in relation to a real budget. Look at how much a funder such as a regional screen agency would provide as funding. Then look at what you have planned and what the reality of shooting would be. How much will your locations cost? How many crew members will you have to take out to your location and so on? How would you reduce the cost without reducing quality?

8

Shoot an advert. Adverts are often masterclasses in how to tell a story quickly and efficiently.

POST-PRODUCTION

**Apocalypse Now
(dir: Francis Ford Coppola 1979)**

Editing the film is only one of the activities involved in the post-production process, which will take you right through to exhibition and distribution.

Of all the film-making stages, the process of post-production is the part where you can take a breather for a moment. Time will still be pressured. Edit suites and post-production sound facilities still cost money and time will be a factor for everyone, but this is the point where you are working with only a few members of the team. If your planning has worked well then you'll be ready to edit creatively and see your film emerge in front of your eyes.

This is the point where colour is corrected and sound, graphics and music are added. The whole project moves from a series of images into a film.

However, it is a mistake to think that post-production ends with the final edit. A film is only a film if someone sees it and the more people who can see it the more value it has for you and the audience. This is where your planning around distribution and exhibition really pays off.

There will now be fewer people around than at any other point in the process. Remember that as a director, you will not normally be in charge of the editing process, at least in terms of the technicalities. You will not normally be pressing the buttons on the edit suite. A working knowledge of what is possible is essential but your editor is in charge of this aspect of the process – otherwise you wouldn't need an editor at all. This extends to the whole post-production team.

As a director, you are still in charge but it is a mistake to think that the post-production team are merely functionaries who are there to carry out your wishes. They are creative individuals, specialists who can advise, suggest and be creative *with* you rather than *for* you.

Your producer is also still around and is still important. This is the final stage where the film is created and they will be making sure that it matches the expectations of the financial backers or the studios. They'll also be keeping an eye on the schedule. Time is money and the post-production stage is where time can easily run away with you. Similarly, if you are working on a low- or no-budget short and editing in your bedroom you are in danger of letting time run away with you. The perfectionist will continue to tweak their film forever. Always set yourself time limits and so save your sanity.

Production – what should have been completed

- Shots should have been logged.
- Shots should have been checked.
- Sound should have been checked.

- Post-production sound effects should have been collected.
- Crew should have been signed off.

 If any of the above are incomplete, then return to the beginning of Chapter 3 and start again.

The post-production team

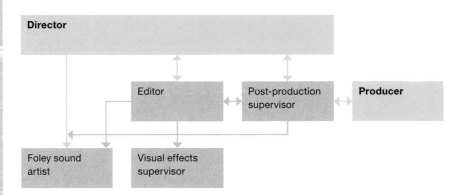

This part of the process is where you deal with a few key individuals and spend a great deal of time in a dark room making judgements on your own work. Like every other part of the process, everyone is there to do a job and communication is important. Your closest relationship will be with the editor.

Finalising your film

The editing process is the final stage of making the film, and it is this process that tests your success in planning and executing the film shoot. Everything you've done so far should help make this part of the process a successful and truly creative experience. However, in addition to the existing work, there are also new elements that you must introduce at this stage. A film isn't a film without sound and music. It is a mistake to think that sound is what you have recorded on location. Most films rely on post-production sound to create mood; the Foley artist is vital, creating the natural, everyday sound effects on the film. Your composer will have been working to generate a score which needs to be added to emphasise the emotional impact of the film. There are also aspects such as colour correction that require attention to give your film consistency. The final touches are visual effects – but these should only be used if you *need* them, don't add them just because you can. This final stage is where the film is made from the pieces created in production; this is the last chance to make the film in your head a reality.

This is the part that I like most in the process, to edit and try to find (the story). Sometimes you think you have a film, and then you change something and it becomes different. It's a wonderful job. Because it surprises you.

Fernando Meirelles, director, writer and producer

The post-production process

```
                          ┌──────────────┐
                          │ Studios/     │
                          │ financiers   │
                          └──────┬───────┘
                                 ↕
┌─────────────────────────┐   ┌──────────────┐
│ Director                │↔  │ Producer     │
└──────────┬──────────────┘   └──────┬───────┘
           │                         ↕
           ├────────────────────→  ┌──────────────┐
           │                       │ Festivals    │
           │                       └──────┬───────┘
           │                              ↕
           ├────────────────────→  ┌──────────────┐
           │                       │ Press        │
           │                       └──────┬───────┘
           │                              ↕
           └────────────────────→  ┌──────────────┐
                                   │ Screenings   │
                                   └──────────────┘
```

In sharp contrast to every other phase of production, this is where you start to hand over some control. This is where the producer comes into their own and begins to shape what will happen to the film once it is finished. However, this is at the organisational and promotional level. You are still the person in creative control and you need to have your say.

The days of cutting celluloid are now all but gone. The visceral act of slicing the film with a razor blade and splicing together the thin strips is, for most, a long-distant memory. The advent of non-linear editing systems has allowed for a speedier and smoother process. It is also very much cheaper.

This is to the benefit of the low-budget film-maker, who can easily have access to high-powered hardware and high-quality software at a fraction of the cost of only a few years ago.

The editor

Editing the images together is the start of the process and is essential before beginning the process of layering any detailed sound, titles or visual effects. In low-budget film production you are unlikely to have a post-production supervisor and so an editor or producer normally fulfils this role in addition to their standard duties. As a head of department, an editor will also supervise the rest of the post-production process. On a feature film shoot, the editor will supervise a number of assistants as well as a title designer.

As a director, you are working with them to produce a director's cut, which then goes to the producers. The impact and nature of this depends on who has funded your project. The producer may be looking at the film in relation to a funder, a studio or in relation to the festival it is going to.

Non-linear editing

Non-linear editing is the name given to computer-based forms of editing. It refers to the ability to access any frame individually and in any sequence. This has replaced the linear forms of tape editing where, if an error was made, the process had to be started from the beginning. Even feature films are run through a process called telecine (where film is 'captured' to a computer) and then edited as with other recording forms.

As a director, you should use both the technical and creative skills of the editor to cut the film. However, it is still your film and your responsibility to get the edit right; you remain in overall creative control. Most professional editors work with a separate monitor to the standard computer monitor that shows the various windows listed in the box below. This allows you a bigger view and will give you a more accurate sense of what the colours look like. If you don't have access to this then focus your attentions on the preview window for viewing the cut. When getting down to the detail, take the time to look at the timeline. This will separate the image, text, graphics, effects and layers of sound. You will be able to see exactly at what point transitions and so on occur and you can request slight and precise adjustments.

Non-linear editing: The windows

The timeline
This shows a graphic representation of the running order of your film. This is where you can trim shots, add effects such as fades and importantly where you can manipulate the sound and music.

Preview window
This window allows you to view the footage in the 'bin'.

Play window
This is the window that shows the footage as it has been edited on the timeline.

Digital cut window
This is the window that controls the film that you export back to your mastering source. For many festivals this is back to tape, but may be as a file or as a DVD.

Capture window
This window (sometimes with a graphic representation) is the list of footage you have captured and which is available for the specific project.

RF Select
This shows all the footage that is available to you from all your projects and files.

Grammar is a term normally associated with written language; however it is also commonly applied to film-making. This is because cinema has its own visual language with its own codes and conventions. In any language, meaning is generated not by individual words but rather by their combination, order and punctuation – in film-making, this meaning is created through editing. Audiences are so well versed in the language of film that they no longer need to question what they see on screen; they understand without conscious questioning. Therefore, the best editing often goes unnoticed. A script provides narrative continuity. The edit should provide visual and auditory continuity.

Before you get your hands on any of the machinery, it is useful to undertake a paper edit. This is often mistakenly though of as a simple paper version of what happens on screen, but it is much more than that. You will have the logs of all recorded material, you should also have a rough assembled version that you created as you were shooting. This rough version will help you see what material is available to you. The paper edit involves going back to the script and making sure that you are still making meaning – even if that meaning is different from where you started. Think about structure, about causality and about characterisation.

Getting involved

Even the most basic computer can be used for post-production but the addition of twin monitors or a large monitor will help; as will good-quality speakers and an output monitor to ensure an accurate colour balance. As the basic equipment has become more accessible, the editing software has now also become more user-friendly and intuitive than ever before. The combination of these factors has led many directors to become more involved in editing their own work.

If you choose to become involved in the editing process, it is still very important to work with an editor to help you get it right. The technique of editing is not just about pressing the right buttons. A skilled editor will also understand the nature and form of editing. As director, you'll know your story and your footage better than anyone else, but this knowledge has to be put together with the skill and knowledge of an editor.

Editing – history and context

The history of film-making starts around 120 years ago with the advent of film itself. However, conceptually, it starts long before this with triptychs in churches and comic strips in newspapers. These separate images that collectively make a narrative flow were the inspiration for early film directors. In the early stages of film production, a significant leap forward was made with the recognition that through editing narrative, compression of time could be made. From then on, the process was cemented.

In the first half of the 20th century, the most notable exponent of this new form of editing was D.W. Griffith, who in turn influenced a new generation of directors. In Griffith's work, it is not simply a process of compressing time. Editing allows for a change of scene, a move to a new place and, very importantly, a change in the type of shot being used. This led to the move from a long shot to a close-up for dramatic reasons. Prior to this, the emphasis had been on the *mise-en-scène* in a theatrical style. This is where the language of film began to develop. In many ways, the language of film is a language of editing. Contemporary audiences rarely see the edit (when it works well), but this is only because we are now versed in the vocabulary that was developed in the early days of film production.

Film editing is now something almost everyone can do at a simple level and enjoy it, but to take it to a higher level requires the same dedication and persistence that any art form does.

Walter Murch, film editor and sound designer

Editing terms and techniques

The advent of new software packages for editing and for the whole production process allows for a whole array of impressive techniques; but using them all will not make for a better film. They must be used with discretion; understanding the practice of film editing and the vocabulary associated with it is essential.

- Cut: The change from one scene to the next, without any form of visual break. This can also be the generic name used in discussion to suggest moving from one scene to the next. Cuts are always 'motivated', in that the audience expect something to happen. In its simplest form, this is where you would move between mid-shots in a conversation. The motivation might be to reveal action that has been suggested in conversation.
- Continuity editing: Where action is seamless on screen; action moves progressively.
- Cross cutting: The movement between two or more plot lines so that they appear simultaneous on screen.
- Dissolve: The blending of one scene into the next.
- Establishing shot: Where the scene is set; normally a view of where the action is about to take place.
- Eye match: Where the actors are made to look as if they are looking at each other via the cut.
- Fade: Normally where the image fades to black and then out again to another scene.
- Jump cut: Where moves between significant sequences of action occur leaving gaps in the literal sequence but not necessarily in the narrative flow.
- Matched cut: Where there is a connection between the two images that are linked. Normally this is a direct and literal link but can also be used in different ways, for example in Alfred Hitchcock's The 39 Steps (1935) where there is an innovative match cut between a close-up of a woman screaming and a train.
- Montage: A sequence where meaning is determined through the editing together of images. This can be metaphoric (as in the work of Sergei Eisenstein) or literal (to compress time).
- Reverse shot: A mode of filming that is important in showing reaction or over-the-shoulder shots during long passages of dialogue.

- Sequence shot: A long take where no editing is required. This is a good shot to practise integrating as a method of considered and careful editing.
- Split screen: Where the screen is broken into smaller screens to show various views of the same action or different actions all at the same time. *The Boston Strangler* (dir: Richard Fleischer 1968) used this to show multiple levels of panic and the detail of the crimes. The unusual nature of spilt screen, in addition to the content of the film, makes this uncomfortable but pertinent viewing.
- Wipe: Where there is clear sense of a slide from one frame to the next. This can be left to right or up and down. This is very much a historical form of edit. It is used in *Star Wars IV: A New Hope* (dir: George Lucas, 1977) to suggest the Saturday morning serials of the 1930s and 1940s which it echoes.

Time Code (dir: Mike Figgis 2000)

Mike Figgis used the concept of split screen to narrative effect in *Time Code*. This film is an interesting experiment but makes for difficult viewing.

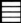
CASE STUDY

Sergei Eisenstein

Sergei Eisenstein was born in Riga, Russia, in 1898.
He was a pioneer of cinema in a whole range of fields, but
it is for his theories of editing that he is best remembered.

Eisenstein (along with his teacher and contemporary Lev Kuleshov)
believed the power of cinema lay in montage. Therefore, for
Eisenstein, the unique quality of cinema was in the process of editing.
For him, the nature of the edit was not to simply have a linear realistic
presentation of a narrative. The power of editing was in the creation
of an emotion in the mind of the audience through the collision of
images. This work was based on Kuleshov's famous effect where
shots of an actor were intercut with various seemingly unrelated
images, such as a child crying and a coffin. When quizzed about their
impressions, disparate members of the audience would often agree
about the meaning of the apparently random images – in this case
the audience might conclude that a father had died. Eisenstein's early
films use this effect, often in the context of a revolutionary narrative.
In *October*, Eisenstein shows the corruption of the government
officials in power juxtaposed against statues of the Tsar.

Filmography

The following six films are variants on Eisenstein's theory of montage.
Each uses montage in relation to narrative in different ways. The
narrative in *The General Line*, for instance, is much more fragmented
than that in *The Battleship Potemkin*, but the ultimate aim of editing in
the form of montage remains the same.

- *Glumov's Diary* (1923)
- *Strike* (1925)
- *The Battleship Potemkin* (1925)
- *October: Ten Days that Shook the World* (1927)
- *The General Line* (1929)
- *¡Que Viva Mexico!* (1931)

Eisenstein's last four films represented a departure from his earlier
work. These films demonstrate a concern for conventional narrative
structure and, while they are innovative in their camera work and
special effects, the editing is notable for its adherence to convention.
It is no coincidence that this relates to the dominance of Stalin.

- *Alexander Nevsky* (1938)
- *Ivan the Terrible, Part 1* (1944)
- *Ivan the Terrible, Part 2* (1945)
- *Ivan the Terrible, Part 3* (unfinished) (1946)

Eisenstein wrote a great deal about the theory and practice of cinema. His intellectualising of process was unusual at the time and has been highly influential since. His master works are:

- *Film Form: Essays in Film Theory*
- *The Film Sense*
- *Towards a Theory of Montage*

Conclusion

The work of Eisenstein has been borrowed, copied and augmented throughout time; any investigation of the infamous shower sequence in *Psycho* (Alfred Hitchcock 1960) or the Odessa Steps sequence in *The Untouchables* (Brian DePalma 1987) or *Brazil* (Terry Gilliam 1985) demonstrates this. The knowledgeable director will look back to help them move forward.

**October: Ten Days that Shook the World
(dir: Sergei Eisenstein 1927)**

October exemplifies Eisenstein's use of montage to create emotion as well as to progress a narrative flow. The use of this form of dynamic editing has been used by many film-makers since. Perhaps most notable and most quoted is Alfred Hitchcock and the infamous shower sequence in *Psycho* (1960).

A film isn't a film until the music and sound have been added. Sound includes speech as well as sound effects and music and all three have to be balanced. There is no such thing as *natural* sound in film. It has all been manipulated and altered, balanced and mastered. This is to make the constructed and essentially artificial nature of film appear seamless and real. Sound and music is subtle; it allows you to have an impact on an audience in ways you might not have otherwise considered.

Foley

Foley is named after Jack Foley (1891–1967), a Hollywood sound editor who is credited as being the first person to systematise the use of post-production sound effects on a film. This is in essence what 'Foley' is; the layering of sound on a film during post-production.

In a feature film, there would normally be a Foley artist who works with a recording engineer under the post-production supervisor; of course, all of this would be under the creative instruction of the director. In a low-budget context, this is more likely to be one person. If you can get the personnel, it is worth making this someone distinct from the editor who will work on sounds as you work through production and will be able to bring these to the edit the moment it begins. Creating and manipulating sounds is always valuable, otherwise they can feel incongruous and artificial.

In addition to sound effects, Foley also refers to the whole soundscape of the film. This may include manipulating the location sound recording or creating a wild track of ambient or 'natural sound'. Foley can also refer to the re-recording of voices once the filming is finished.

Working with the composer

Ideally, you will have been working with a composer from the start of the process. The composition of a score for a film can take a very long time and should be a process of negotiation between the composer and yourself. This is where two creative roles come together and is one place where collaboration normally occurs.

If you have given the composer the script and visual clues during pre-production you should have something to listen to by the time you get to post-production. The composer may want access to footage as you progress in production and, if it helps them, then there is no reason not to give it to them.

Sound desk

There is no such thing as 'pure' sound in cinema. All sound is mixed and levels balanced. This can be done via a sound desk or by using the edit software of a virtual sound mixer.

Case study: Sergei Eisenstein > **Sound and music** > The finishing touches

What is the composer composing?

At this point in post-production, you should have been in regular dialogue with your composer. It is important to have heard extracts or samples of their ideas. If you haven't, you could be in for a shock. As a general rule of thumb, you have more creative control where you may have commissioned original songs to appear. These are written as songs for the film, but not to fit necessarily with the scenes you have cut. You can thus edit these as required.

A feature film often has more than just a score, it may also contain different forms of music or even recognisable songs. This can happen when you are actually working with more than one composer to construct the musical backdrop to your film. Remember that copyright law means that incorporating existing music into your film will prevent you from screening your film without paying for the rights – and that isn't cheap.

Film music

- The soundtrack is the musical backdrop to the film, which gives pace and emotion.

- Title music is the music that opens the film. This normally has lyrical content that matches the content of the film. Often this is part of the overall soundtrack and is a developed refrain.

- Credit music is played as the credits roll. In recent Hollywood films this is often a song by a known artist included in order to help publicise the film.

The final sound edit

Editing with music is often the aspect of post-production that really brings the film together in unity. It is the aspect that gives the film a pace and a dynamic that might otherwise be lacking. Many composers will have very specific requirements for how they wish to work with film.

The normal sound-editing process is:

- A rough outline of the music to be produced so both you and the editor have a sense of what it sounds like.
- A rough cut of the film is presented to the composer so that the two can be matched.
- The film is then finalised in relation to the music.
- Listening to a good sound mix is vital. Headphones are good to get focus on the final sound mix, particularly when mixing music and sound together. Using a set of high-quality speakers, ideally quad sound, will get you closer to the mix you need – the sounds the audience will hear in the cinema.

Bear in mind that the sound edit is no less tricky than any other stage of the film-making process and as such you shouldn't expect this to be quick. Time spent with the Foley artist will be time well spent. Like all other aspects of what you have made, film sounds are specific to film language. Punches never really sound like they do on screen, bombs never whistle when dropped from a plane and tyres rarely screech – but an audience expects them to. The best sound edit is never heard; the best sound edit makes your film sound like a movie.

A film isn't finished until all the final details are sorted out. Even with the music layered on top, there are a number of things that need finalising. This is where your film takes on the professional sheen that is essential for it to compete against all the other films that are out there. If a film you admire appears to be roughly finished, you can bet that this effect has taken a great deal of time to create.

Visual effects

This is a specialist job, normally undertaken by a variety of skilled post-production individuals. The technologies required to add visual effects are becoming increasingly cheap, but there are still specialist skills required to do them well. We've all seen films that are heavily laden with stunning effects but which are let down by poor story telling or even poor acting. Effects should be applied judiciously and this is down to you as director.

Historically, visual effects were tied to genre, mainly in the creation of settings or characters, and are particularly noticeable in science-fiction, horror and action films. Many effects are generated onset but post-production visual effects are different and are more widespread than many people think. The nature of post-production effects is now so widespread that they are the norm within feature films, but they are still relatively unusual within shorts.

In addition to the genre-driven effects so familiar in mainstream cinema, there are subtler effects that can be used. These include changing colours and lighting effects. New and emergent post-production technologies allow you to hide a multitude of sins, although there is no substitute for getting it right on set.

> Special effects are characters. Special effects are essential elements. Just because you can't see them doesn't mean they aren't there.
>
> Laurence Fishburne, actor

Common effects

Where specific effects such as blue screen have been used this will have been considered in pre-production and will have factored in post-production. Other commonly used effects include:

- CGI (computer-generated imagery): The use of 3D computer-generated effects in live-action film.

- Models: Small-scale models that are represented in and as the scale of the film world – now rarely used.

- Rotoscoping: Where the film is traced and represented as animation. This is now done using digital technologies, such as in *A Scanner Darkly* (dir: Richard Linklater 2006). It can be used for an aspect of film, perhaps most famously with the lightsabre effect in the *Star Wars* series.

- Animation: Where the complete scene is created as an animated form. May be used as a scene, for example in *Natural Born Killers* (dir: Oliver Stone, 1994).

- Matte: The creation of a backdrop, either as a painted, photo-generated, animated or CGI 3D backdrop. Can be either a still or moving image.

- Compositing: Drawing together multiple effects.

A Scanner Darkly
(dir: Richard Linklater 2006)

With *A Scanner Darkly,* Richard Linklater became the first director to use digital rotoscoping to create an entire feature film. The attempt was to make what was essentially an animated film, but the visual effect is striking and close enough to live action to make for slightly unnerving viewing. This captures the mood of Philip K. Dick's novel.

Sound and music > **The finishing touches** > Exhibition and distribution

**Anatomy of a Murder
(dir: Otto Preminger 1959)**

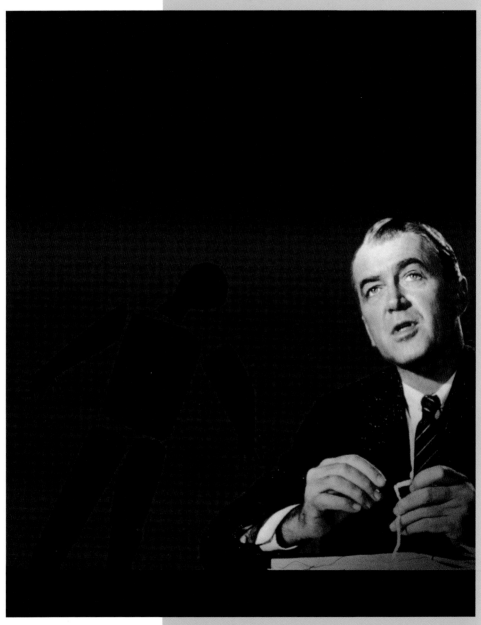

Saul Bass is famous for complex title sequences that are as memorable as the films themselves. These are not only great publicity but give a sense of what the film will be about.

Titles

Titles are often an afterthought, which is a mistake, as they are usually the first thing that an audience sees. They are there from the moment the film opens on the screen and therefore form part of the whole viewing experience. Even when a director such as Ingmar Bergman or Woody Allen, use simple white words on a black background, this in itself makes a statement.

Consider whether you want to integrate the titles into the film. Your audience will be used to film as a form and therefore will expect to see at least the name of the film. Look at a Hollywood feature; the names you see are normally the stars, the studio and the well-known director. In the low-budget short film, the names are not normally so well-known. Having too much at the start can be very off-putting; it can even be seen as arrogant.

Credits

In the early days of cinema, credits came at the start of the film and the actors' names appeared again and in full at the end. This shifted with the introduction of larger crews and more actors requiring credits. Feature film, unlike any other industrial medium, requires that all concerned have a credit somewhere on screen.

There is a useful aspect of the credits, which may be determined by the producer. This is a place where logos and names appear – the people who have supported you financially or otherwise, during all or part of the film-making process. Convention dictates that all this appears at the end.

Colour correction

Even with the most experienced DoP, you will find that your footage looks different depending on the conditions in which it was filmed. This is likely to be even more noticeable in short, low-budget films. The oft-shouted phrase *we'll fix it in post-production* is fatal. There are some problems that cannot be fixed. However, it is important to know in advance that you will have to level colour in the same way that you have had to level sound – otherwise you may feel some initial panic when you first see the rushes. The process of colour correction is undertaken after the film has been cut; this is to avoid wasting time and money in correcting footage that will not appear in the finished work. For this reason, if you examine the out-takes or deleted scenes on a DVD, you may notice the different colour quality and 'rougher' feel to the film.

It is for you as director to determine the colour and, just as importantly, the tone of each scene. The tone and hue of the colours you employ will be as important to the mood of your film as the music you use. For example, if you watch the Coen brothers' *O Brother, Where Art Thou* (dir: Joel Coen, 2000) you'll see how the sepia tones perfectly fit the period setting.

The function of colour correction

- Ensures there is a match of colour between scenes filmed in different conditions.

- Creates mood.

- Makes footage shot in daylight look like night.

- Matches shots where different cameras have been used (although this is to be avoided in production if possible).

- Corrects issues caused by incorrect white balance (getting this right is the responsibility of your camera operator).

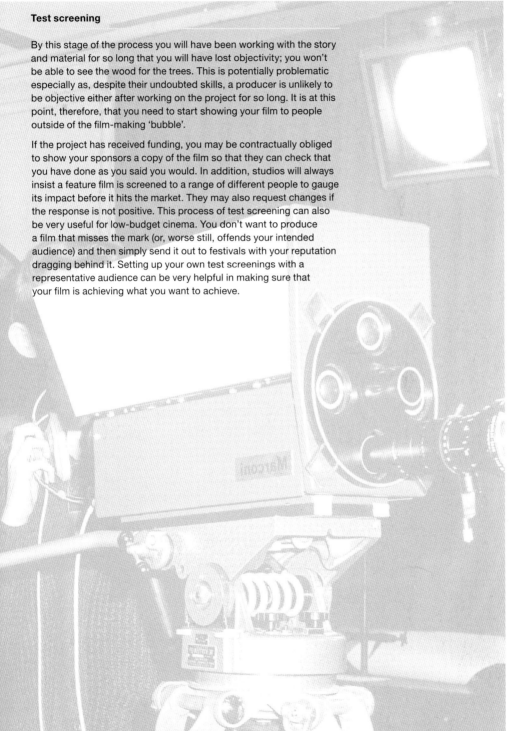

Test screening

By this stage of the process you will have been working with the story and material for so long that you will have lost objectivity; you won't be able to see the wood for the trees. This is potentially problematic especially as, despite their undoubted skills, a producer is unlikely to be objective either after working on the project for so long. It is at this point, therefore, that you need to start showing your film to people outside of the film-making 'bubble'.

If the project has received funding, you may be contractually obliged to show your sponsors a copy of the film so that they can check that you have done as you said you would. In addition, studios will always insist a feature film is screened to a range of different people to gauge its impact before it hits the market. They may also request changes if the response is not positive. This process of test screening can also be very useful for low-budget cinema. You don't want to produce a film that misses the mark (or, worse still, offends your intended audience) and then simply send it out to festivals with your reputation dragging behind it. Setting up your own test screenings with a representative audience can be very helpful in making sure that your film is achieving what you want to achieve.

A film isn't a film until someone has seen it. A film is a medium intended for a wide audience, and exhibition and distribution are therefore the final stage in the film-making process. Normally your producer will have been working on this throughout the project and, of course, if you have been making something specifically for a festival your focus will already be on that audience. While it is the responsibility of the producer to organise where the film will be shown, as director you will play an important part in the process of selling the work. The director is the person that everyone wants to see and meet, so you can be a big part of promoting your film.

It's worth bearing in mind that exhibition and distribution are two very different things. Exhibition is about showing your work. Distribution is about securing a deal for your film to be shown across a range of cinemas or to be included on a disc. As a low-budget film-maker, you have far more options to exhibit your work than distribute it. Even sources such as YouTube should be seen as exhibition rather than distribution.

Networking

Networking is an absolutely vital skill to hone and develop as you progress in your profession. It is particularly important when you have completed a film that you are proud of and which is evidence of your skill. Subject-specific online networks such as Shooting People (the international networking organisation that supports and promotes independent film-making) are particularly useful, especially when they help to bring people together face-to-face to meet and discuss their ideas.

When you are at an industry event, meeting people who could influence your future career, it is important to present yourself as a professional who is making film as a career. The skills required to do this are manifold but there are consistent aspects you should always employ and everything is driven by the event that you are attending.

- Be prepared: Have a business card ready; know your material.
- Research: Know who may be attending an event.
- Be presentable: Context dictates everything.
- Approach: Be ready to talk to people and engage in discussion, but never interrupt.
- Belief: You have something valuable to contribute.
- Listen: Other people have something valuable to say.
- Discuss: You may have differing opinions, but discuss rather than violently disagree.

Screening

Organising your own screening is one strategy to get your film seen. If you decide to take this route, then make sure you give yourself plenty of time to organise it properly. Consider who the audience for the film is and whether it will form part of a much bigger event. Being part of a larger occasion is usually more suitable for a short film that would not be an evening's entertainment all on its own. Perhaps consider showing it in a social environment, such as a bar or café, or liaising with other entertainers to create a range of events.

Attempting to have your film shown at a major cinema before a feature film is always an option. Note that, most of the time, this is very difficult, as the chain and the studio who have produced the feature will have to have a say in what is shown – and this could be extremely difficult to arrange.

Having good publicity always helps but, for your own reputation you need to be sure that the event will be a success. Local press and radio are often interested in people making films. It is a sexy business, after all. Make sure that you have enough of an audience to make it look well-attended and ensure it is well organised. It is always worth inviting all the people who were involved in or who helped with the production of the film – they are always enthusiastic when viewing their work on the big screen and will aid the mood of the event. If you have organised your own screening, you will need to speak. You are the director – the person who put the film together, and the audience will want to hear you speak. Be brief and always allow the audience the opportunity to ask questions.

Festival entry

Film festivals are always the best option for having your work seen by as wide an audience as possible. However, there are more than 3,000 film festivals worldwide every year, which is both a blessing and a curse. It is great because there are plenty of festivals for you to enter but it reduces the chances of your film being seen by the small number of studio heads out there.

Many festivals charge an entry fee and while this is standard practice, you should always be wary about this. Before you hand over your hard-earned cash, think about the profile of the festival you are sending your work to? Is it worth the money?

- Start with a local small-scale festival. You are more likely to have your film seen.
- Identify festivals who deal with the subject matter and form you have used.
- Don't discount festivals overseas, they may be right for your work even if you can't be there.
- Use this exposure as a springboard to get your next film shown at a more prestigious festival.
- Most of all – try. Films have to be shown in festivals and you never know. Your film might be viewed well by a selection panel. Reach for the stars.

Be careful about submitting your film to too many festivals without clearly checking their criteria. Many festivals insist on premières – you could fall foul of this if you submit to a number of festivals at the same time. If your strategy is to have your film seen by as many people as possible, then avoid those who employ this rule.

The main task of this festival is to discover, promote and help regional authors and producers. Our red carpet is reserved only for them.

Miro Purivatra, director of the Sarajevo Film Festival

Film festivals

The list below identifies some of the key film festivals by location.

UK

- Belfast: Belfast Film Festival
- Bradford: Bradford International Film Festival
- Bristol: Encounters International Short Film Festival
- Edinburgh: Edinburgh International Film Festival
- Glasgow: Glasgow Film Festival
- Leeds: Leeds International Film Festival
- London: Filminute – The International One-Minute Film Festival
- London: London Independent Film Festival
- London: Raindance Film Festival

USA

- Hollywood: International Student Film Festival Hollywood
- Los Angeles: Los Angeles International Short Film Festival
- Los Angeles: AFI Fest - Los Angeles International Film Festival
- Maitland: Florida Film Festival
- New York: New York Underground Film Festival
- San Francisco: San Francisco Independent Film Festival
- Utah: Sundance Film Festival

Canada

- Montreal: Montreal World Film Festival
- Toronto: Canadian Film Centre's Worldwide Short Film Festival
- Vancouver: Vancouver International Film Festival

Europe

- Athens: Athens International Film Festival
- Berlin: Berlin International Film Festival
- Clermont-Ferrand: Clermont-Ferrand International Short Film Festival
- Dresden: Filmfest Dresden - International Short Film Festival
- Dublin: Dublin International Film Festival
- Oberhausen: Oberhausen International Short Film Festival
- Tampere: Tampere International Short Film Festival

CASE STUDY

Miles Watts

The Bandwagons was directed by first-time feature director Miles Watts. This was an unusual endeavour as with no money, very little equipment and very little crew, he embarked on the production of a feature film. Watts undertook the project having gained experience of working on a range of short films under the umbrella of the Hum-drum Films collective. Hum-drum is based in York in the North of England and was founded and managed by Miles Watts, Finn Riley, and Ryan de Koning in the Spring of 2007.

They provide an excellent example of how using a local network of film talent can produce results. The basis is a nucleus of people who work as a collective in order to make shorts, taking directorial roles in each others' films. By assisting others to make no-budget films, they have drawn together a crew of people who engage in each others' work.

Do it yourself

From this base, Miles Watts established Miles to Go Productions: 'Miles to Go Productions is an independent film company based in York. We believe in efficient, no fuss, low-budget, high-quality film-making that entertains and inspires, and we work with film-makers new and experienced to make the films we want to make.'

In order to maintain their profile and keep publicity high, the company produces Zomblogalypse, a low-budget zombie series uploaded to YouTube and shown via <www.zomblogalypse.com> This strategy has seen a hardcore of colleagues become part of an ongoing project and also seen a large number of fans consistently 'tuning in'. These YouTube fans form a potential audience for, and supporters of, new work from the company.

Getting it to the people

The Bandwagons went through an unusual process to end up on screen. The wide community involvement made for a very keen and enthusiastic local audience for the work when it was premièred at an independent Picturehouse cinema. The presentation of the film for a viewing audience was highly professional and maintained the ethos developed during production – a high-budget look for a low-budget film.

The professionalism of this production coupled with the dynamism of the companies involved (Hum-drum and Miles to Go) has led to heightened interest in the artists' future work and Miles to Go Productions is currently making a new film, *Crimefighters*.

Conclusion

When you start out as a film-maker, getting your work seen has to be a priority. In the case of *Bandwagons* the successful, local exhibition has led to more exposure for the new film *Crimefighters* and will lead to even more success in the future. Working with likeminded colleagues in your community is a great way to get your films made and exhibited.

**The Bandwagons
(dir: Miles Watts 2006)**

A professional publicity poster for a very low-budget feature. It looks like a Hollywood movie and draws together other publicity shots.

The legal issues associated with consent, clearance and copyright are really jobs that your producer should handle for you. However, as your name is high on the list of credits, it is well worth familiarising yourself with the terms and the implications of not adhering to the rules, regulations and legal obligations. As with all issues that relate to the law, it is well worth checking any specifics with the relevant authorities, and the information below is presented as an initial guide.

What is consent?

Consent is the signed agreement between those involved in the film production as to how their work can be used in the future. Your producer is responsible for checking this but it is worthwhile understanding this as you may at some point wish to show your film in a context that might contravene the terms of the consent.

Consent is normally seen as being applicable to actors and any member of the public who may appear in a scene. However it should also be applied to the whole crew. While it may seem like a lot of effort to get consent from everyone involved with the project, it is advisable to cover all eventualities. Many distributors and cinemas want to know that you have consent from all involved so they don't then become liable for breach of copyright. Be absolutely clear about the rights you hold; if you sign to say that consent has been sought and attained when it hasn't, you could be personally liable. Check with your producer.

What is clearance?

'Consent' and 'clearance' are sometimes used as interchangeable terms. However, it is a useful rule of thumb to consider consent as being applicable to people and clearance as being applicable to things. This may include images such as photographs, art or music, even when the music has been re-recorded. It also includes company trademarks. It is worth checking what is available before you get into the edit. No matter how much you really want or even need a particular shot, if it accidentally shows a shopfront, for example, and you don't have the right clearances, then you could be liable. Music is the single biggest issue for low-budget films. *Always* gain clearance and give yourself plenty of time to do so.

What is copyright?

Copyright is the protection of originality in a variety of forms. Copyright opens up issues of intellectual property, even though this is sometimes intangible. Different countries consider issues of copyright in different ways but the overall principles are generally the same. As director or director/writer, the issue of breach of copyright is more likely to fall on your shoulders than anyone else's. It is vital that you ask the production team to check for breach of copyright at every stage and reflect on your own practice to make sure there has been no contravention.

Often, many issues of copyright theft are debated around intent. Plagiarising is easy to do when you are so immersed in cinema and the lines between an homage and theft are quite fine. While intent to copy is difficult to prove, the intent not to is equally difficult to defend, particularly when the material is evident on screen.

How do you gain copyright?

Copyright is automatic when your film is made and exhibited as long as it was intended to exist in a permanent form. This can include the recording on DVD, tape and so on. Without any registering, the default position for film copyright is to the director and producer. This can be different if produced by a studio or if copyright is handed over to a funder. If you are interested in assigning copyright to your work, then it is worth putting a statement in the titles to this effect (including the date). This is known as asserting your right to be identified as the creator of the piece. This is the formal notice of the originality of the work. Copyright exists for 70 years for the director, producer and composer. Performers have rights over their own performance for 50 years. This is the case even if the clearance clearly shows that no money has changed hands.

Common breaches of copyright

It is always worthwhile checking details but the majority of breaches of copyright are:

- Text: Where a script or narrative flow is taken directly from an original source. You cannot adapt a book to a film without the relevant clearances and written agreements.

- Names: Either products or actors' names, where the name or brand is trademarked.

- Logos: The rules are tricky in this regard and not clear-cut, but it is best to avoid logos where possible.

- Music: Whether it is the original piece or a re-recording. Many contraventions occur with the use of classical music where the original score is out of copyright but a particular performance and recording is under copyright.

- Brands: It is best to avoid major brands. If in doubt, it is worth acquiring a redesign from a production designer.

- Properties: If you plan to include a unique, original item such as a one-off design or a commissioned product in your film, you may need to seek permission from the copyright owner. Architecture often falls into this category.

Making sure you have it right

Making sure you have everything signed off and all aspects of copyright and clearance are adhered to is a collective responsibility. With actors, it is down to the personal assistant and first assistant director on set. With locations, it is your location manager. Normally, a producer would have an eye on the images to check nothing has appeared on screen that shouldn't have. On a low-budget shoot, you may not have these members of the team and people may be doubling up. Your name will be the one that heads up the film, so make sure you have double-checked.

Be careful when you sign the contract

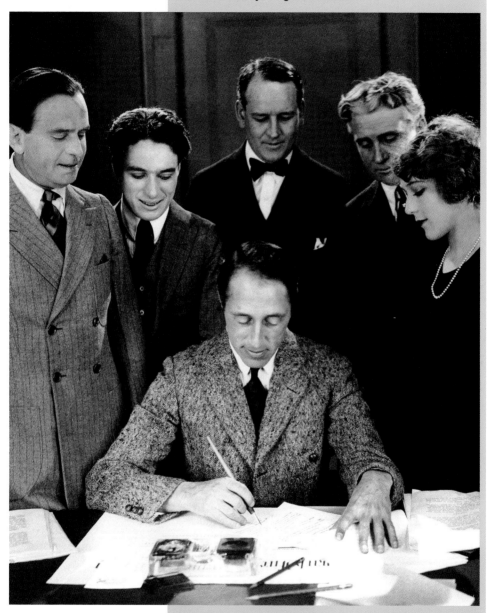

Douglas Fairbanks, Charlie Chaplin, D.W. Griffith and Mary Pickford sign a contract with their lawyers. This was the contract that would make United Artists into a major player in international cinema. The contracts you sign might not feel this important, but they might be – especially if you haven't read them properly.

Case study: Miles Watts > **Consent, clearance and copyright** > Mark Herman interview

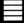

INTERVIEW

Where do you start?

By the end of the shoot, the editor has a rough cut already set. I take a week off and then go down to London, and he has a 2.5 hours rough cut, more than an assembly. Working with available sound at that stage – for a number of weeks. I am involved when we are out there so I know how the rough cut is coming along. Now I've stopped saying 'I want take four' as there are good bits in four and five and six. I almost work from memory now.

When does the sound edit start?

We'd get close to a first directors' cut and then get the sound guys in and go through every scene, then we'd sit down and discuss it and all make suggestions – what needs cleaning up and what needs adding, and they'd come up with inventive stuff. On *Pyjamas* I wanted a sense of heat – they get a brief and then go out and find It. In *Little Voice* all the furniture has its own sound, all of which adds to the character of the house and its tackiness.

How do you work with composers?

I worked with John Altman on *Little Voice*, which was a very different experience from James Horner on *Pyjamas*. We talk about the tone of the film – then it's over to them. James played a refrain on the piano, and you have to be more musically trained than I am to see what he is seeing. But you trust to their skill. The mix is where it happens, where it comes together, and it gets very tense.

How does the screening work and how useful is it for you?

At that point you are working with a temp score, normally, as it goes out to a test screening. It's most useful being on a temp screening, more with a comedy than anything else. It is useful to have a test screening, with a lot of people in the room with you.

And distribution?

The marketing is a major period where you have no control, the film is handed over to someone who presumably knows their job, and you bow to their better knowledge and have to go with it. Your instincts matter for nothing, you've had your chance, you aren't a marketing person.

And you have to promote the finished film?

It is relentless, and some people are very good at it. In New York for *Little Voice*, they took over a hotel, each with their own room. Watching Michael Caine on the monitor was incredible, every interview looked like the first time he'd been asked the question. The Q&As are more interesting and with *Pyjamas* you needed to be so sensitive. Although in America I did say 'Hollywood' rather than 'Holocaust' a few times.

**Little Voice
(dir. Mark Herman 1998)**

With *Little Voice*, Mark Herman took something that was written for stage and made it live on screen. The Jim Cartwright play was adapted for, and utilised the talents of, Jane Horrocks.

EXERCISES

Your film will soon be 'in the can'. You have seen an assembled version as you go along and have already undertaken any re-shoots that are necessary. Now you are ready to do the edit and get your work out there.

1

Volunteer to assist with the editing on someone else's film. You don't need to be an editor, you could simply capture footage; looking at how someone else works is always valuable.

2

Take rushes from anywhere you can and edit them, and then look back at the original edit. How did your interpretation differ?

3

Take a still from each scene from your film. Can a prospective audience member read this photo-story? If not, there may be a problem.

4

Try editing a scene from your film without a paper edit and then the next with. Which is the most efficient for you?

 Take sequences from different genres and look at how the editing differs. Classic films become classics for a reason and looking at the edit is important in these. Hitchcock and Truffaut, amongst many others, are well worth viewing.

 Watch a silent movie or a scene from a 'talkie' where there is little or no dialogue while playing a range of different soundtracks. Note how this fundamentally affects the meaning of the film.

 Attend a festival, no matter how small. You are a film-maker and this is your time to start networking. You are going to meet contacts so think what you are going to say to them. How are you going to present yourself? What questions are you going to ask?

Organise an event for another film-maker.

This book has taken you through a process and has given you some examples of how different directors work. The most frustrating thing you will have probably realised is that no one can really teach you how to direct. You can certainly be taught elements of technique and you can listen to a lot of advice, but the best thing you can do is to get out there and practise. That is why a clear understanding of process is so important. You don't have to stick slavishly to established practice, but if you veer away from it, you need to have clear reasons for doing so and know what the implications may be. The essential three stages of pre-production, production and post-production will never change. While modes of exhibition and distribution may change, the means of making your film will not.

Making a film can be a long process; becoming an expert director doesn't begin and end with your first film. Some directors are lucky enough to be 'discovered' on their first short, but this is unusual. You need to be prepared for this to be something you will need to repeat. Get into the habit of collating ideas. Get to know people who are like-minded. Ideas and people are two of the most important things you need. Everything else will follow.

What is clear is that there are a number of qualities to be developed as you embark on directing your film:

- Creativity: Without this your film will not truly be yours.

- Originality: You need to push the boundaries and not resort to a pastiche of your favourite directors.

- Critical judgement: No matter how long you have been developing something, if it is fundamentally flawed then you have to let it go.

- Discipline: Making a film isn't easy or quick.

- Tenacity: Making a film is fraught with difficulties – don't let that put you off.

- Confidence: You have the ideas and ultimately you are in control.

- Study: This might be reading (and judging) books on film, taking classes, talking to friends, watching a great deal or a combination of all of these things.

- Persistence: Getting a film to the point where it can be made is hard, making it is no easier. Persistence and being single-minded is valuable.

- Humility: Film production is a team process. Listen to the advice of others.

- Research: Know your medium

- Luck: Everything might go wrong – but then again it might just go right...

Without a director a film would remain as literature. A screenwriter may originate an idea, but only a director can bring it to life. As a director you are ultimately responsible for the whole production and that's a good thing. Get all of this right and you will ultimately receive the accolades you deserve. Good luck!

There are many sources of information about making short films and many resources that can be used. Much of this is user-generated content, written for amateurs or first-time directors. This doesn't mean that it is of no use. As long as you are able to evaluate the information you are reading, then read it. There are common processes, but the context of each production is different. This is what makes it so fascinating.

The proliferation of internet video sites brings its own complications for distribution but it is also an opportunity to see work outside of the festival circuit. Again it is the process of evaluation of the work that is so useful. Festival sites as well as MySpace and YouTube are valuable resources in seeing as many films as possible but it is important to remember that they won't all be good. The presence of online networks such as Facebook and Bebo provide the opportunity for easy contact with teams of people. There are also many networks that operate at a local level, for example the South Yorkshire Filmmaker's Network <www.syfn.org>. Consider how you could start your own local network if there isn't one in your neighbourhood.

It's also worth bearing in mind that, although there are many courses that claim to teach you about film production, some are better than others. Courses run at or hosted by universities and colleges are validated and checked for quality. If you are paying for a non-university-based course make sure you check the credentials and background of those delivering it.

Web resources

Drew's Scriptorama is an invaluable resource of known scripts on which you can practise; try visualising them and then watch the film. See how far they match: **www.script-o-rama.com**

Most countries have a Director's Guild, for instance: **www.dggb.org, www.dga.org** and **www.dgc.ca**

The National Film Board of Canada: **www.nfb.ca**

Sites such as **www.mandy.com** cover a range of jobs and options to advertise your production or find crew.

The BBC Film Network is an excellent general start and a good place to view shorts: **www.bbc.co.uk/dna/filmnetwork/Filmmakingguide**

The Channel 4 and Film 4 site is similar in focus and contains good interview material: **www.channel4.com/film**

The British Film Institute (BFI) **www.bfi.org.uk** and the American Film Institute (AFI) **www.afi.com** provide comprehensive and consistently updated information.

Skillset is the UK Sector Skills Council looking after film. They are very helpful on production roles and job prospects: **www.skillset.org/film**

In Britain, the various Regional Screen Agencies and National Screen Agencies list a huge amount of information and lists of local opportunities, links can be found at: **www.skillset.org/film/knowledge/links/article_2495_1.asp**

There are many specific casting resources and sites that you can visit, for example **www.uk.castingcallpro.com**

BECTU is the union for all media professionals and contains up-to-date information on the industries: **www.bectu.org.uk**

The Motion Picture Association of America holds a wealth of information: **www.mpaa.org**

The Australian Film Commission (AFC) is Australia's major film development agency: **www.afc.gov.au**

Software

Storyboard and structuring software includes:

1. StoryBoard Quick
2. StoryBoard Artist
3. StoryBoard Pro
4. FrameForge 3D
5. SpringBoard

Celtx provides one of the most useful integrated pieces of software, including storyboards. And it's free.

A brief bibliography

The majority of the books listed below are specifically about being a director, but also included are some useful overview titles that seek to cover the whole film production process.

- Bloom, M – *Thinking Like a Director: A Practical Handbook* (Faber and Faber, 2001)
- Crisp, M – *Directing Single Camera Drama* (Focal Press, 1992)
- Dmytryk, E – *On Screen Directing* (Focal Press, 1984)
- Figgis, M – *Digital Filmmaking* (Faber and Faber, 2001)
- Katz, S – *Film Directing Shot By Shot: Visualizing From Concept to Screen* (Michael Weise, 1991)
- Katz, S – *Film Directing: Cinematic Motion* (Michael Weise, 2004)
- MacKendrick, A – *On Film-Making* (MacMillan, 2005)
- Mamet, D – *On Directing Film* (Penguin, 1992)
- Murch, W – *In the Blink of an Eye: A Perspective on Film Editing* (Silman-James Press, 2001)
- Ray, S – *Our Films Their Films* (Hyperion, 1994)
- Travis, M – *Directing Feature Films* (Michael Weise, 2004)
- Vidor, K – *King Vidor on Film Making* (McKay, 1972)
- Vineyard, J – *Setting Up Your Shots: Great Camera Moves Every Filmmaker Should Know* (Michael Weise, 2000)
- Weston, J – *Directing Actors: Creating Memorable Performances for Film and Television* (Michael Weise, 2001)
 There are also a number of journals and trade papers you can read that will provide great contextual information:
- *Cahiers du Cinéma*
- *Independent Film Quarterly*
- *Kinoeye*
- *Screen*
- *Screen Digest*
- *Screen International*
- *Sight and Sound*

It is also worth reviewing the University of Mississippi Press *Conversations With Filmmakers* series and the Faber & Faber *Directors on directors* (such as *Mike Leigh on Mike Leigh*).

Key directors

Presenting a list of directors is inevitably reductionist. The list below is merely as an introduction to directors who work in a variety of styles and who utilise, or utilised, a range of methods for production. Watching any film from any of these directors will prove useful and informative, but you should also make your own list of favourites. Most people do this by finding a film that hits them on an emotional level. In the first instance, it is the film that should draw you to the cinema, not necessarily the director. Watch as much as possible. Even if you don't like a film, it should be an informative experience; as long as you can articulate the strengths and weaknesses and build on them in your own work the time spent watching will be time well spent.

Akerman, Chantal	Keaton, Buster
Allen, Woody	Kiarostami, Abbas
Almódovar, Pedro	Kubrick, Stanley
Altman, Robert	Kurosawa, Akira
Anderson, Paul	Lee, Spike
Bergman, Ingmar	Leigh, Mike
Bigelow, Kathryn	Leone, Sergio
Boulting, John and Roy	Lester, Richard
Chaplin, Charles	Linklater, Richard
Coen, Joel	Loach, Ken
Cox, Alex	Lumet, Sidney
Crichton, Charles	Lynch, David
Cronenberg, David	Polanski, Roman
Davies, Terence	Pollack, Sidney
Eastwood, Clint	Potter, Sally
Eisenstein, Sergei	Powell, Michael
Ephron, Nora	Ramsay, Lynne
Fassbiner, Rainer	Renoir, Jean
Ferrara, Abel	Roeg, Nicholas
Fincher, David	Rohmer, Eric
Frears, Stephen	Scorsese, Martin
Gilliam, Terry	Sokurov, Aleksander
Godard, Jean-Luc	Truffaut, François
Griffith, D.W.	Van Sant, Gus
Hartley, Hal	Von Trier, Lars
Haynes, Todd	Weir, Peter
Herman, Mark	Wenders, Wim
Herzog, Werner	Wilder, Billy
Hitchcock, Alfred	Winterbottom, Michael
Jarmusch, Jim	Yates, David
Jonze, Spike	Yimou, Zhang

Filmography

In any book of this sort you would expect to find a list of films of note – and here it is. There is always a problem with lists of this sort; they leave things out. You can learn from viewing any film, even if you feel it isn't particularly good. In fact you can sometimes learn more from a bad film than a good one; the flaws are easy to see. When a film is great it tends to hit you at an emotional level and it is thus harder to see the artistry at work.

The list represents not only important films but important directors. It is worth viewing the complete canon of work by an individual director.

The list below is not definitive. It is a list of films I think are important and films that regularly make it to the 'best of' lists. While reductive, these lists are useful to gauge critical and popular success. If you are stuck for something different *Halliwell's Film Guide* and the *Virgin Film Guide* are invaluable resources and are published annually. It is also worth looking at the highest box-office returns and seeing how this lines up with the critics' choices. There may be some surprises.

Akerman, Chantal
Toute une Nuitrraldo
1982

Aldrich, Robert
Whatever Happened to Baby Jane?
1962

Aldrich, Robert
Kiss Me Deadly
1955

Aldrich, Robert
The Dirty Dozen
1967

Allen, Woody
Shadows and Fog
1992

Allen, Woody
Manhattan
1979

Allen, Woody
Annie Hall
1977

Allen, Woody
Hannah and Her Sisters
1986

Allen, Woody
Zelig
1983

Allen, Woody
The Purple Rose of Cairo
1985

Almodóvar, Pedro
Bad Education
2004

Almodóvar, Pedro
*Women on the Verge
of a Nervous Breakdown*
1988

Altman, Robert
Nashville
1975

Altman, Robert
Short Cuts
1993

Anderson, Lindsay
This Sporting Life
1963

Anderson, Lindsay
If...
1968

Anderson, Paul Thomas
There Will Be Blood
2007

Anderson, Paul Thomas
Boogie Nights
1997

Antonioni, Michelangelo
Blow Up
1966

Badham, John
Saturday Night Fever
1977

Benigni, Roberto
Johnny Stecchino
1992

Benigni, Roberto
Life is Beautiful
1998

Bergman, Ingmar
Seventh Seal
1956

Bergman, Ingmar
Wild Strawberries
1957

Bigelow, Kathryn
Strange Days
1995

Bogdanovich, Peter
The Last Picture Show
1971

Boorman, John
Zardoz
1973

Boorman, John
Deliverance
1971

Boyle, Danny
Slumdog Millionaire
2008

Brooks, Mel
Young Frankenstein
1974

Brooks, Mel
Blazing Saddles
1974

Browning, Todd
Freaks
1932

Buñuel, Luis
Belle De Jour
1967

Buñuel, Luis
Un Chien Andalou
1928

Burton, Tim
Sleepy Hollow
1999

Burton, Tim
Edward Scissorhands
1990

Cameron, James
The Terminator
1984

Campion, Jane
The Piano
1993

Campion, Jane
Angel at My Table
1990

Carne, Marcel
Les Enfants du Paradis
1945

Chaplin, Charles
Limelight
1952

Chaplin, Charles
Modern Times
1936

Cimino, Michael
The Deer Hunter
1978

Clair, René
Le Million
1931

Coen, Joel
Miller's Crossing
1990

Coppola, Francis Ford
The Godfather Part 2
1974

Coppola, Francis Ford
Apocalypse Now
1979

Coppola, Sofia
Lost in Translation
2003

Corman, Roger
Little Shop of Horrors
1960

Crichton, Charles
Lavender Hill Mob
1951

Cuarón, Alfonso
Harry Potter and the Prisoner of Azkerban
2004

Curtiz, Michael
Casablanca
1942

Daldry, Stephen
The Reader
2008

Dearden, Basil
The League of Gentlemen
1960

DePalma, Brian
The Untouchables
1987

DeSica, Vittorio
Bicycle Thieves
1948

Dominik, Andrew
The Assassination of Jesse James by the Coward Robert Ford
2007

Donen, Stanley
Singin' in the Rain
1952

Eastwood, Clint
High Plains Drifter
1973

Eastwood, Clint
Unforgiven
1992

Eastwood, Clint
Gran Torino
2008

Eisenstein, Sergei
Battleship Potemkin
1925

Ephron, Nora
Sleepless in Seattle
1993

Farrelly, Bobby and Peter
There's Something About Mary
1998

Fassbinder, R.W.
Handler der vier Jareszeiten
1971

Fellini, Federico
8 ½
1963

Fellini, Federico
La Strada
1954

Fellini, Federico
La Dolce Vita
1960

Ferrara, Abel
Bad Lieutenant
1992

Figgis, Mike
Timecode
2000

Figgis, Mike
Leaving Las Vegas
1995

Fincher, David
Fight Club
1999

Fincher, David
Se7en
1995

Ford, John
The Searchers
1956

Ford, John
Stagecoach
1939

Forman, Milos
Amadeus
1984

Forsyth, Bill
Local Hero
1983

Forsyth, Bill
Gregory's Girl
1980

Frankenheimer, John
The Manchurian Candidate
1962

Frears, Steven
Sammy and Rosie Get Laid
1987

Friedkin, William
The Exorcist
1973

Furie, Sidney J.
The Ipcress File
1965

Gance, Abel
Napoleon
1927

Garnett, Tay
The Postman Always Rings Twice
1946

Gilliam, Terry
The Fisher King
1991

Gilliam, Terry
Twelve Monkeys
1995

Gilliam, Terry
Brazil
1985

Glazer, Jonathan
Sexy Beast
2000

Godard, Jean-Luc
Breathless
1959

Greenaway, Peter
The Draughtsman's Contract
1982

Greenaway, Peter
The Cook, The Thief, His Wife and Her Lover
1990

Griffith, D.W.
The Birth of a Nation
1915

Griffith, D.W.
Intolerance
1916

Grune, Karl
Die Strasse
1924

Hamer, Robert
School for Scoundrels
1960

Hamer, Robert
Dead of Night
1945

Hamer, Robert
Kind Hearts and Coronets
1949

Hardy, Robin
The Wicker Man
1973

Hartley, Hal
Amateur
1994

Hawks, Howard
Rio Bravo
1959

Heerman, William
Animal Crackers
1930

Herman, Mark
Brassed Off
1996

Herman, Mark
Little Voice
1998

Herman, Mark
The Boy in the Striped Pyjamas
2008

Herzog, Werner
Aguirre, Wrath of God
1972

Herzog, Werner
Fitzcarraldo
1982

Hill, George Roy
The Sting
1973

Hill, Walter
48 Hours
1982

Hiller, Arthur
Out of Towners
1970

Hitchcock, Alfred
North by Northwest
1959

Hitchcock, Alfred
Psycho
1960

Hitchcock, Alfred
The Thirty-Nine Steps
1935

Hodges, Mike
Get Carter
1971

Hopper, Dennis
Easy Rider
1969

Horne, James
Way Out West
1937

Howard, Ron
Frost/Nixon
2008

Hughes, John
Ferris Bueller's Day Off
1986

Huston, John
The African Queen
1951

Huston, John
The Treasure of the Sierra Madre
1948

Jackson, Peter
Bad Taste
1988

Jarman, Derek
Sebastiane
1977

Jarmusch, Jim
Stranger than Paradise
1984

Jarmusch, Jim
Down by Law
1986

Jeunet, Jean-Pierre
Amélie
2001

Jewison, Norman
The Russians Are Coming
1966

Jonze, Spike
Being John Malkovich
1999

Jordan, Neil
The Crying Game
1992

Kaige, Chen
Farewell My Concubine
1993

Kar-Leung, Lau
Drunken Master 2
1994

Kaufman & Herz
Toxic Avenger
1984

Kaurismaki, Aki
Leningrad Cowboys Go to America
1989

Kazan, Elia
On the Waterfront
1954

Keaton, Buster
The General
1927

Kieslowski, Krysztof
Blanc
1994

Korda, Alexander
The Private Life of Henry VIII
1933

Kore-eda, Hirokazu
Maborosi
1995

Kubrick, Stanley
The Shining
1980

Kubrick, Stanley
Barry Lyndon
1975

Kubrick, Stanley
Dr Strangelove
1964

Kubrick, Stanley
A Clockwork Orange
1971

Kubrick, Stanley
Full Metal Jacket
1987

Kurosawa, Akira
Ran
1985

Kurosawa, Akira
Rashomon
1950

Kurosawa, Akira
The Seven Samurai
1954

Kurosawa, Akira
Hidden Fortress
1958

Landis, John
The Blues Brothers
1980

Lang, Fritz
Metropolis
1926

Lang, Fritz
The Big Heat
1953

Lang, Fritz
M
1931

Laughton, Charles
The Night of the Hunter
1955

Lean, David
Lawrence of Arabia
1962

Lean, David
Great Expectations
1946

Lean, David
Brief Encounter
1946

Lee, Ang
Eat Drink Man Woman
1994

Lee, Spike
She's Gotta Have It
1986

Lee, Spike
Do the Right Thing
1989

Lehmann, Michael
Heathers
1988

Leone, Sergio
Once Upon a Time in America
1984

Leone, Sergio
Once Upon a Time in the West
1968

Leone, Sergio
The Good, The Bad and the Ugly
1966

Lester, Richard
Finders Keepers
1983

Lester, Richard
How I Won the War
1967

Lester, Richard
A Hard Day's Night
1964

Linklater, Richard
Slacker
1991

Loach, Ken
Kes
1969

Lucas, George
Star Wars IV: A New Hope
1977

Lumet, Sidney
12 Angry Men
1957

Lumet, Sidney
Network
1976

Lynch, David
Blue Velvet
1986

MacCarey, Leo
Duck Soup
1933

Mackendrick, Alexander
The Man in the White Suit
1951

Mackendrick, Alexander
The Ladykillers
1955

Malick, Terrence
Days of Heaven
1978

Mankiewicz, Joseph
Sleuth
1972

Marshall, George
The Ghost Breakers
1940

Mazursky, Paul
Moscow on the Hudson
1984

McTiernan, John
Diehard
1988

Meadows, Shane
Dead Man's Shoes
2004

Meadows, Shane
A Room for Romeo Brass
1999

Meadows, Shane
This Is England
2006

Melville, Jean-Pierre
Le Samurai
1967

Mendes, Sam
American Beauty
1999

Menzel, Jiri
Closely Observed Trains
1966

Meyer, Nicholas
Star Trek: The Wrath of Khan
1982

Meyer, Nicholas
Star Trek VI: The Undiscovered Country
1991

Meyer, Russ
Faster, Pussycat! Kill! Kill!
1965

Miller, George
Mad Max
1980

Ming-Liang, Tsai
Aiqing Wansui
1994

Minghella, Anthony
The English Patient
1996

Minnelli, Vincente
Meet Me in St Louis
1944

Monteiro, João Cesar
A Comedia de Deus
1995

Conclusion > Directing and film resources > Picture credits

Mulchay, Russel
Highlander
1986

Murnau, F.W.
Sunrise
1927

Murnau, F.W.
Nosferatu
1922

Nichols, Mike
The Graduate
1967

Nichols, Mike
Working Girl
1988

Nolan, Christopher
The Dark Night
2008

Ozu, Yasujiro
Late Spring
1949

Ozu, Yasujiro
An Autumn Afternoon
1962

Pakula, Alan J.
Parallax View
1974

Pakula, Alan, J.
All the President's Men
1976

Parker, Alan
Birdy
1984

Payne, Alexander
Election
1992

Peckinpah, Sam
The Wild Bunch
1969

Peckinpah, Sam
Straw Dogs
1971

Peterson, Wolfgang
Das Boot
1981

Polanski, Roman
Cul de Sac
1966

Polanski, Roman
Chinatown
1974

Polanski, Roman
Repulsion
1965

Pollack, Sidney
Three Days of the Condor
1975

Powell, Michael
A Canterbury Tale
1944

Powell, Michael
Peeping Tom
1960

Powell, Michael
A Matter of Life and Death
1946

Powell, Michael
Red Shoes
1948

Powell, Michael
The Life and Death of Colonel Blimp
1943

Preminger, Otto
Laura
1944

Raimi, Sam
Evil Dead
1983

Ramis, Harold
Groundhog Day
1993

Ray, Nicholas
Knock on Any Door
1949

Ray, Nicholas
Rebel Without a Cause
1955

Ray, Satyajit
Pather Panchali
1955

Reed, Carol
The Third Man
1949

Reitman, Ivan
Ghostbusters
1984

Renoir, Jean
La Grande Illusion
1937

Renoir, Jean
La Règle du Jeu
1939

Richter, W.D.
The Adventures of Buckaroo Banzai Across the 8th Dimension
1984

Rodriguez, Robert
From Dusk till Dawn
1996

Roeg, Nicholas
Walkabout
1971

Roeg, Nicholas
Performance
1970

Rohmer, Eric
Claire's Knee
1970

Rossellini, Roberto
Rome, Open City
1946

Schlesinger, John
Midnight Cowboy
1969

Scorsese, Martin
Mean Streets
1973

Scorsese, Martin
Taxi Driver
1976

Scorsese, Martin
After Hours
1985

Scorsese, Martin
The King of Comedy
1982

Scott, Ridley
Bladerunner
1981

Seiter, William
Sons of the Desert
1933

Siegel, Don
Charley Varrick
1973

Siegel, Don
Invasion of the Body Snatchers
1956

Siegel, Don
Dirty Harry
1971

Singer, Brian
The Usual Suspects
1995

Singleton, John
Boyz N the Hood
1991

Soderbergh, Steven
Sex, Lies and Videotape
1989

Spielberg, Steven
Saving Private Ryan
1998

Spielberg, Steven
Duel
1971

Spielberg, Steven
Jaws
1975

Stevens, George
Shane
1953

Stiller, Ben
Zoolander
2001

Sturges, Preston
Sullivan's Travels
1941

Svankmajer, Jan
Conspirators of Pleasure
1996

Tarantino, Quentin
Pulp Fiction
1994

Tarkovsky, Andrei
Solaris
1971

Tarkovsky, Andrei
Stalker
1979

Tarr, Béla
Panelkapcsolat
1982

Thomas, Gerald
Carry on Cleo
1964

Truffaut, François
Jules et Jim
1961

Varnel, Marcel
Oh, Mr Porter!
1937

Vertov, Dziga
Man With a Movie Camera
1929

Vidor, King
The Big Parade
1925

Vidor, King
Duel in the Sun
1946

Von Stroheim, Eric
Greed
1924

Von Trier, Lars
Riget/Kingdom
1995

Von Trier, Lars
Breaking the Waves
1996

Waters, John
Pink Flamingos
1972

Waters, Mark
Mean Girls
2004

Welles, Orson
Citizen Kane
1941

Welles, Orson
Touch of Evil
1958

Wenders, Wim
Wings of Desire
1988

Wenders, Wim
Paris Texas
1983

Whale, James
Frankenstein
1931

Wiene, Robert
Das Cabinet des Dr Caligari
1920

Wilder, Billy
The Private Life of Sherlock Holmes
1970

Wilder, Billy
Irma La Douce
1963

Wilder, Billy
Sunset Boulevard
1950

Wilder, Billy
Double Indemnity
1944

Wilder, Billy
The Apartment
1960

Wilder, Billy
Some Like it Hot
1959

Wilder, Billy
The Lost Weekend
1945

Wilder, Billy
The Seven Year Itch
1955

Wise, Robert
West Side Story
1961

Wise, Robert
The Day the Earth Stood Still
1951

Wood, Sam
A Night at the Opera
1935

Wyler, William
Ben Hur
1959

Yates, David
Harry Potter and the Half-Blood Prince
2009

Zampi, Mario
The Naked Truth
1957

Zinnemann, Fred
A Man for All Seasons
1966

Pages 2–3:
Lost in Translation, 2003.
The Kobal Collection.

Page 9:
Munich, 2005.
Dreamworks Skg/Universal /
The Kobal Collection / Karen Ballard

Page 12:
The Eiger Sanction, 1975. Universal /
The Kobal Collection.

Pages 16–17:
The Lost Squadron, 1932.
RKO / The Kobal Collection

Page 23:
Dancer image © Galina Barskaya.
Cinema image © Marten Czamanske.
www.shutterstock.com

Page 25:
The Shining, 1980.
Warner Bros / The Kobal Collection

Pages 28–29:
Manhattan, 1979.
United Artists / The Kobal Collection /
Brian Hamill

Page 31:
*Flapwing and The Last Work
of Ezekiel Crumb*, 2006.
Alasdair Beckett-King.

Page 34:
*An Alan Smithee Film: Burn Hollywood
Burn*, 1998. Hollywood Pictures /
The Kobal Collection / John Bramley

Page 38:
*Doctor Strangelove: Or How I Learned
To Stop Worrying And Learned To Love
The Bomb*, 1963.
Hawk Films Prod/Columbia /
The Kobal Collection

Page 49:
Elevator Gods, 2006.
Peter Hunt

Page 51:
© Katrina Brown/istockphoto

Page 53:
Battleship Potemkin, 1925.
Goskino / The Kobal Collection

Page 54–55:
*The Assassination Of Jesse James
By The Coward Robert Ford*, 2007.
Warner Bros/Plan B/Scott Free /
The Kobal Collection /Kimberley French

Page 61:
Dead Man's Shoes, 2004.
Warp Films/Big Arty Productions /
The Kobal Collection

Page 63:
All or Nothing, 2002.
Thin Man/Alain Sarde/Studio Canal /
The Kobal Collection / Simon Mein

Page 71:
Hope Springs, 2003
Buena Vista/Touchstone /
The Kobal Collection

Pages 74–75:
Apocalypto, 2006
Icon Ent/Buena Vista /
The Kobal Collection / Andrew Cooper

Page 79:
El Mariachi, 1993
Los Hooligans/Columbia /
The Kobal Collection

Pages 82–83:
*The Cook, The Thief, His Wife
And Her Lover*, 1989
Allarts/Erato / The Kobal Collection

Page 87:
The Brothers Grimm, 2005
Dimension / Miramax / The Kobal
Collection

Page 91:
Casablanca, 1942
Warner Bros / The Kobal Collection /
Jack Woods

Page 95:
Raging Bull, 1980
United Artists / The Kobal Collection

Page 96:
© Mihai Simonia
www.Shutterstock.com

Page 97:
© Soundsnaps
www.shutterstock.com
© 2009 Sennheiser UK Ltd.

Page 98:
© Tea And Rtimags
www.shutterstock.com

Page 99:
© Pitroviz
www.shutterstock.com
© 2008 The Tiffen Company Llc
All Rights Reserved.

Page 100:
© Deshacam
www.shutterstock.com.

Page 105:
*The Cardiac Oak, Or A Death
In The Darkling Wood,* 2006
Alasdair Beckett-King 2006.

Page 107:
*Tristram Shandy
A Cock And Bull Story, 2005*
BBC Films / Newmarket Films /
The Kobal Collection

Pages 116–117:
12 Angry Men, 1957
United Artists / The Kobal Collection

Page 119:
The Boy in the Striped Pyjamas, 2008
Heyday Films / The Kobal Collection

Pages 122–123:
Apocalypse Now, 1979
Zoetrope/United Artists /
The Kobal Collection

Page 133:
Time Code, 2000
Red Mullet Prod / The Kobal Collection /
Marks, Elliott

Page 135:
October Or *Ten Days That Shook
The World*, 1928
Sovkino / The Kobal Collection

Page 137:
© Gaagen, www.shutterstock.com

Pages 142–143:
A Scanner Darkly, 2006
Warner Independent Pictures /
The Kobal Collection

Page 144:
Anatomy of a Murder, 1959
Columbia / The Kobal Collection

Page 153:
The Bandwagons, 2006
Miles Watts.

Page 157:
United Artists' Contract, 1919
Douglas Fairbanks, Charlie Chaplin,
D W Griffith, Mary Pickford,
Albert Banzhaf (Lawyer)
Dennis O'brien (Lawyer)
The Kobal Collection.

Page 159:
Little Voice, 1998
Miramax / The Kobal Collection /
Laurie Sparham

Diagrams By David Shaw.

For their contribution and help:

Alasdair Beckett-King
Paul Butler
Graham Cole
Pete Cook
Dan Crawforth
Anna Hastie
Pete Hunt
Alisha McMahon
Paul Richardson
Miles Watts
Keith Wilds
Kettle Black Films
Hum-Drum Films
Miles to Go Films

Special mention goes to the staff and students of Film and Television Production at York St John University. It just might be the best degree programme in the world. Particularly Dr Jeff Craine for his support.

Thanks go to Caroline Walmsley and Brian Morris at AVA Publishing, and in particular Georgia Kennedy for her expertise and *especially* her patience.

Special thanks to:
Mark Herman, Rosie Toner, John Marland and Jimmy Richards.

Very special thanks to:
Jennifer, Fred and Stewart.

This book is dedicated to Kat, Meredith and Agatha

BASICS
FILM-MAKING

Working with ethics

Lynne Elvins
Naomi Goulder

Publisher's note

The subject of ethics is not new,
yet its consideration within the applied
visual arts is perhaps not as prevalent
as it might be. Our aim here is to help a
new generation of students, educators
and practitioners find a methodology
for structuring their thoughts and
reflections in this vital area.

AVA Publishing hopes that these
Working with ethics pages provide
a platform for consideration and
a flexible method for incorporating
ethical concerns in the work of
educators, students and professionals.
Our approach consists of four parts:

The **introduction** is intended
to be an accessible snapshot of the
ethical landscape, both in terms of
historical development and current
dominant themes.

The **framework** positions ethical
consideration into four areas and
poses questions about the practical
implications that might occur.
Marking your response to each of
these questions on the scale shown
will allow your reactions to be further
explored by comparison.

The **case study** sets out a real
project and then poses some ethical
questions for further consideration.
This is a focus point for a debate rather
than a critical analysis so there are no
predetermined right or wrong answers.

A selection of **further reading**
for you to consider areas of particular
interest in more detail.

Ethical: awareness/ reflection/ debate

Working with ethics

Introduction

Ethics is a complex subject that interlaces the idea of responsibilities to society with a wide range of considerations relevant to the character and happiness of the individual. It concerns virtues of compassion, loyalty and strength, but also of confidence, imagination, humour and optimism. As introduced in ancient Greek philosophy, the fundamental ethical question is *what should I do?* How we might pursue a 'good' life not only raises moral concerns about the effects of our actions on others, but also personal concerns about our own integrity.

In modern times, the most important and controversial questions in ethics have been the moral ones. With growing populations and improvements in mobility and communications, it is not surprising that considerations about how to structure our lives together on the planet should come to the forefront. For visual artists and communicators, it should be no surprise that these considerations will enter into the creative process.

Some ethical considerations are already enshrined in government laws and regulations or in professional codes of conduct. For example, plagiarism and breaches of confidentiality can be punishable offences. Legislation in various nations makes it unlawful to exclude people with disabilities from accessing information or spaces. The trade of ivory as a material has been banned in many countries. In these cases, a clear line has been drawn under what is unacceptable.

But most ethical matters remain open to debate, among experts and lay-people alike, and in the end we have to make our own choices on the basis of our own guiding principles or values. Is it more ethical to work for a charity than for a commercial company? Is it unethical to create something that others find ugly or offensive?

Specific questions such as these may lead to other questions that are more abstract. For example, is it only effects on humans (and what they care about) that are important, or might effects on the natural world require attention, too?

Is promoting ethical consequences justified even when it requires ethical sacrifices along the way? Must there be a single unifying theory of ethics (such as the Utilitarian thesis that the right course of action is always the one that leads to the greatest happiness of the greatest number), or might there always be many different ethical values that pull a person in various directions?

As we enter into ethical debate and engage with these dilemmas on a personal and professional level, we may change our views or change our view of others. The real test, though, is whether, as we reflect on these matters, we change the way we act as well as the way we think. Socrates, the 'father' of philosophy, proposed that people will naturally do 'good' if they know what is right. But this point might only lead us to yet another question: *how do we know what is right?*

You
What are your ethical beliefs?

Central to everything you do will be your attitude to people and issues around you. For some people, their ethics are an active part of the decisions they make every day as a consumer, a voter or a working professional. Others may think about ethics very little and yet this does not automatically make them unethical. Personal beliefs, lifestyle, politics, nationality, religion, gender, class or education can all influence your ethical viewpoint.

Using the scale, where would you place yourself? What do you take into account to make your decision? Compare results with your friends or colleagues.

Your client
What are your terms?

Working relationships are central to whether ethics can be embedded into a project and your conduct on a day-to-day basis is a demonstration of your professional ethics. The decision with the biggest impact is whom you choose to work with in the first place. Cigarette companies or arms traders are often-cited examples when talking about where a line might be drawn, but rarely are real situations so extreme. At what point might you turn down a project on ethical grounds and how much does the reality of having to earn a living affect your ability to choose?

Using the scale, where would you place a project? How does this compare to your personal ethical level (left)?

01 02 03 04 05 06 07 08 09 10

01 02 03 04 05 06 07 08 09 10

Your specifications
What is the impact of your materials?

In relatively recent times, we are learning that many natural materials are in short supply. At the same time, we are increasingly aware that some man-made materials can have harmful, long-term effects on people or the planet. How much do you know about the materials that you use? Do you know where they come from, how far they travel and under what conditions they are obtained? When your creation is no longer needed, will it be easy and safe to recycle? Will it disappear without a trace? Are these considerations your responsibility or are they out of your hands?

Using the scale, mark how ethical your material choices are.

Your creation
What is the purpose of your work?

Between you, your colleagues and an agreed brief, what will your creation achieve? What purpose will it have in society and will it make a positive contribution? Should your work result in more than commercial success or industry awards? Might your creation help save lives, educate, protect or inspire? Form and function are two established aspects of judging a creation, but there is little consensus on the obligations of visual artists and communicators toward society, or the role they might have in solving social or environmental problems. If you want recognition for being the creator, how responsible are you for what you create and where might that responsibility end?

Using the scale, mark how ethical the purpose of your work is.

01 02 03 04 05 06 07 08 09 10

01 02 03 04 05 06 07 08 09 10

Working with ethics

One aspect of film-making that raises an ethical dilemma is the use of historical subjects as storylines. Many film-goers are known to obtain their understanding of historical events from films and many award-winning and popular films are based, although sometimes loosely, on historical happenings. But when these films are created as stories rather than factual documentaries, how much responsibility does a film-maker have for portraying an accurate account? Should the film-maker have artistic licence to use historical material selectively in order to entertain? Is a film-maker an interpreter rather than a reporter? If so, why is the opinion of the film-maker able to carry more influence than that of anyone else? Is the viewer expected to know the difference between a documentary film and a work of entertainment? When historians may differ in their understanding or interpretation of what actually happened, does it matter if the historical details in a film are wrong or inaccurate? Should the intentions of the film-maker ultimately be the point of scrutiny, with the assumption being that the deliberate distortion of facts is more unethical than historical adaptations, if used solely for increased dramatic effect?

In 1918, Denis Kaufman was hired as an assistant at the Moscow Cinema Committee and renamed himself Dziga Vertov (translated as 'spinning top', 'humming top' or the 'spinning gypsy'). Vertov began to edit documentary footage on Soviet weekly newsreels. Avoiding the dry style of typical documentaries of the time, he structured his films journalistically, using associations and links between elements, thereby creating a persuasive and analytical form. By 1921, as the fighting of the Revolution ended, he had become a seasoned film worker and foresaw a crucial role for film in the coming Soviet Union.

Along with his wife, Elizaveta Svilova, and his brother, Mikhail Kaufman, Vertov developed the concept of *kino-pravda* (translated as *film-truth*) through his newsreel series of the same name (*Pravda* was also the title of the official party newspaper). He considered the camera as an astounding 'machine for seeing'; whereby the camera eye (the 'Kino Eye') would help the human eye perceive things it could not otherwise see.

Vertov captured what he deemed to be historically important, such as the renovation of a trolley system or the organisation of farmers into communes. Capturing an unperformed reality was central to being different from fictional, acted films. The people being filmed were never asked permission and the camera was sometimes placed in hidden positions. Vertov's desire was to catch life 'unawares', and he operated under the assumption that the hidden camera does not intervene and therefore does not change or influence actions. People commonly become curious about the camera and will stare, smile or gesture toward it. Such actions become a performance and highlight the difficulty of attempting to capture a 'truthful' representation of what would normally happen if the camera were not present.

Twenty-three issues of the *Kino-Pravda* series were produced over a period of three years; each issue lasted about 20 minutes and usually covered three topics. However, by the time he had produced the 14th episode, Vertov's Kino-Pravda had become so experimental that some critics dismissed his film creations as 'insane'. His strange camera angles, fast cutting, montage editing, experimental split screens and animated inserts attracted unfavourable comments. By the end of the *Kino-Pravda* series, the use of these 'artificialities' gave rise to criticisms of his technique and after little more than ten years his career was effectively over.

Are documentary films more ethical than fictional films?

Is it unethical to film people without their permission?

Would you produce a documentary film to support a political party?

It is far from simple to show the truth, yet the truth is simple.

Dziga Vertov,
documentary film-maker

Working with ethics

Further reading

AIGA
Design business and ethics
2007, AIGA

Eaton, Marcia Muelder
Aesthetics and the good life
1989, Associated University Press

Ellison, David
Ethics and aesthetics in European modernist literature:
from the sublime to the uncanny
2001, Cambridge University Press

Fenner, David E W (Ed)
Ethics and the arts:
an anthology
1995, Garland Reference Library of Social Science

Gini, Al and Marcoux, Alexei M
Case studies in business ethics
2005, Prentice Hall

McDonough, William and Braungart, Michael
Cradle to cradle:
remaking the way we make things
2002, North Point Press

Papanek, Victor
Design for the real world:
making to measure
1972, Thames and Hudson

United Nations Global Compact
The ten principles
www.unglobalcompact.org/AboutTheGC/TheTenPrinciples/index.html